THE BIG DIG AT NIGHT

by Dan McNichol

Photographs by
Stephen SetteDucati

SILVER
LINING
BOOKS

NEW YORK

THE BIG DIG
AT NIGHT

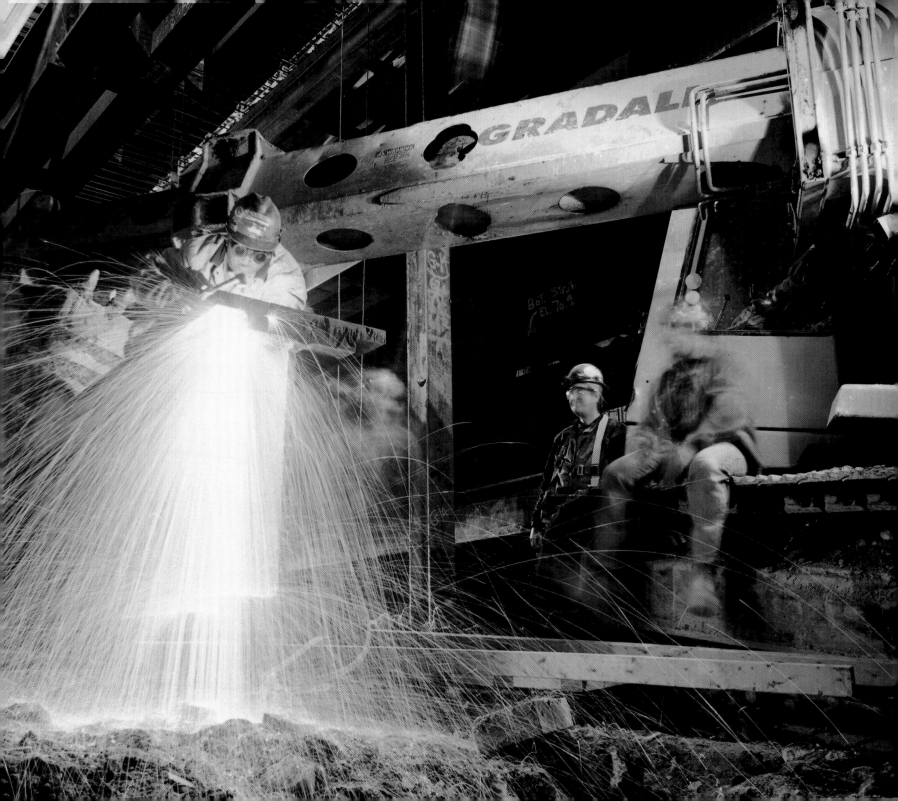

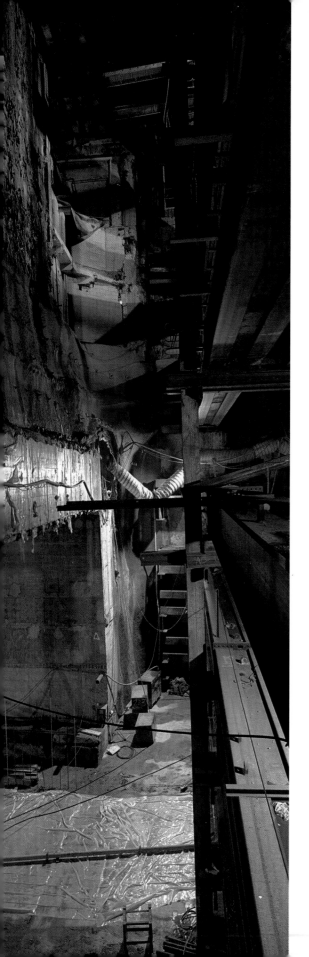

Dedicated to the men and women of the Big Dig
for their commitment to building America's greatest civil project.

Dan McNichol Stephen SetteDucati

For information address:
Silver Lining Books, 122 Fifth Avenue, New York, NY 10011

Silver Lining Books and colophon are registered trademarks.

Editorial Director: Barbara J. Morgan
 Editor: Marjorie Palmer
 Design: Richard J. Berenson
 Berenson Design & Books, Ltd., New York, NY
 Production: Della R. Mancuso
 Mancuso Associates, Inc., North Salem, NY

Library of Congress Cataloging-in-Publication Data is available on request.

ISBN 0-7607-2689-2

Color separation, printing and binding by Sfera International, Milan, Italy

First Edition

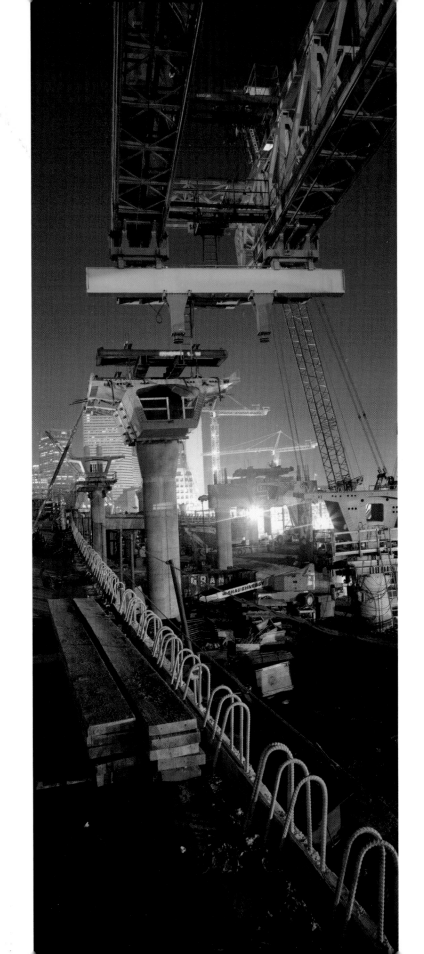

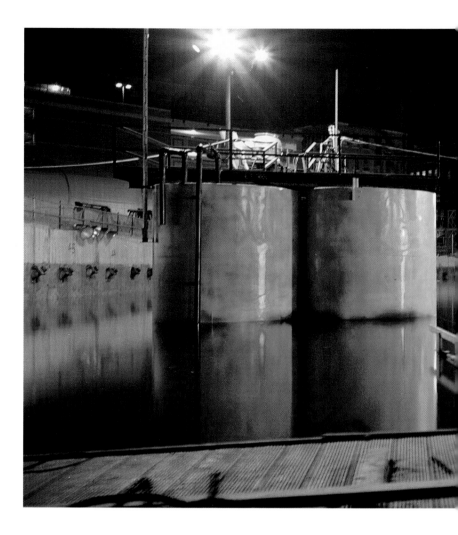

EVERY EVENING, while most people in Boston are winding down their day, an army of workers mobilizes for another night assault on America's greatest civil engineering project, the Big Dig. For these men and women, the day begins at night, "lunch" is at 1:00 a.m., and "quitting time" comes around just as most of us are waking up.

The Big Dig requires the around-the-clock efforts of over 5000 workers. When they are done, 161 miles of highway in an eight-mile-wide corridor will be completed, with nearly half of the project belowground. When the last light is installed, the last tile fixed to a tunnel wall, the Big Dig will complete President Dwight D. Eisenhower's vision of a coast-to-coast highway system, connecting Seattle, Washington, to Boston, Massachusetts, via Interstate 90.

More important to Bostonians, the Big Dig is completing yet another renaissance for this ever changing and dynamic city. The existing downtown highway, a rusting elevated hulk that plows through the heart of Boston, will be gone, replaced by a state-of-the-art tunnel that will finally unsnarl the city's notoriously congested traffic jams. With the elevated highway's demise, the city will not only have an improved mass-transit system and cleaner air, it will also be graced with hundreds of acres of new parks and thousands of freshly planted trees, and it will be reunited with its historic waterfront.

The Big Dig is far too massive to be constructed only during normal working hours. Work continues almost twenty-four hours a day, seven days a week. So, while the city streets are deserted and dark, the construction sites are busy and bathed in artificial light. Excavators

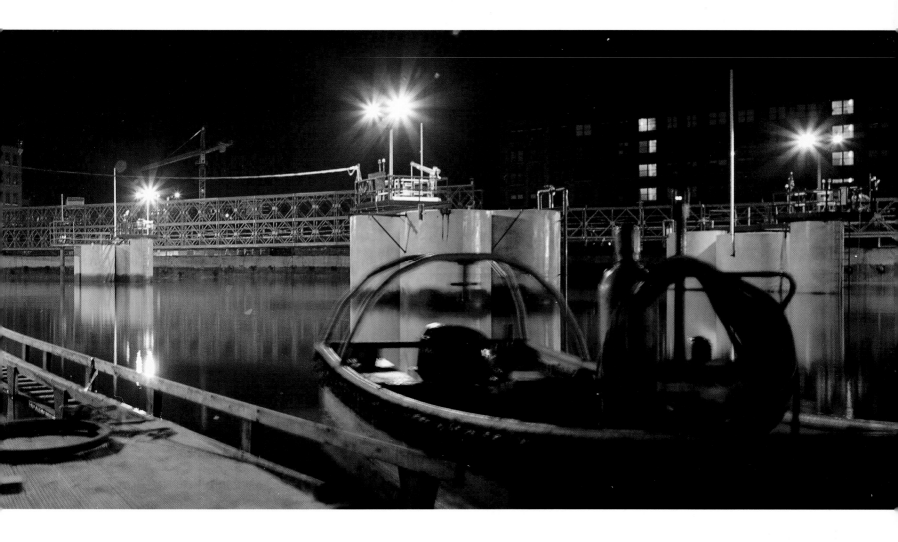

rumble over 100 feet underground; slurry walls are constructed; concrete is poured; tunnels are built beneath towering skyscrapers. The work goes on.

Oddly, in the night we can see what is mostly obscured in the day—the project's mysterious beauty. In the night light, the shapes and forms of the project become clearer. The dedication of its workers becomes more noticeable.

For years, Stephen SetteDucati has followed the glow of the project's construction lights, setting up his photo equipment in the midnight hours, working alongside the men and women of the project in a relationship of mutual admiration and respect. His curiosity and artistry have given us a breathtakingly beautiful visual story of this unique project and the special group of men and women who are doing a job no one has ever done before. Here is all the drama and mystery of what happens every night, above- and belowground, on the largest construction project in the history of the modern world.

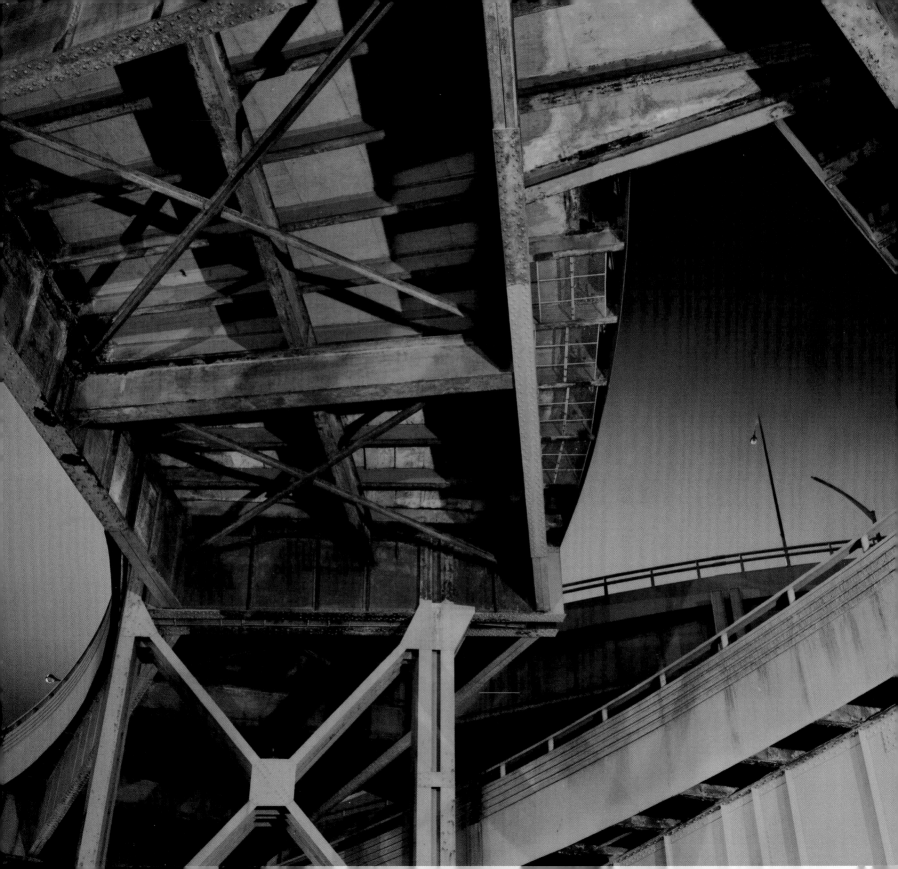

The Highway in the Sky

IN 1951 MASSACHUSETTS began construction on the Skyway, one of the first elevated highways in the United States. By 1953 it was an urban disaster, a hulking presence snaking through the city, dividing Boston's people from each other and from their waterfront. In the end, the Skyway destroyed over thirty-six blocks of neighborhoods, some of them more than three hundred years old, as it ripped a path through people's lives and homes.

Soaring as high as 100 feet into the air, the underbelly of the Skyway's double-deck I-93 interchange is seen here near the Charles River. Taken at 2:17a.m., March 12, 1997.

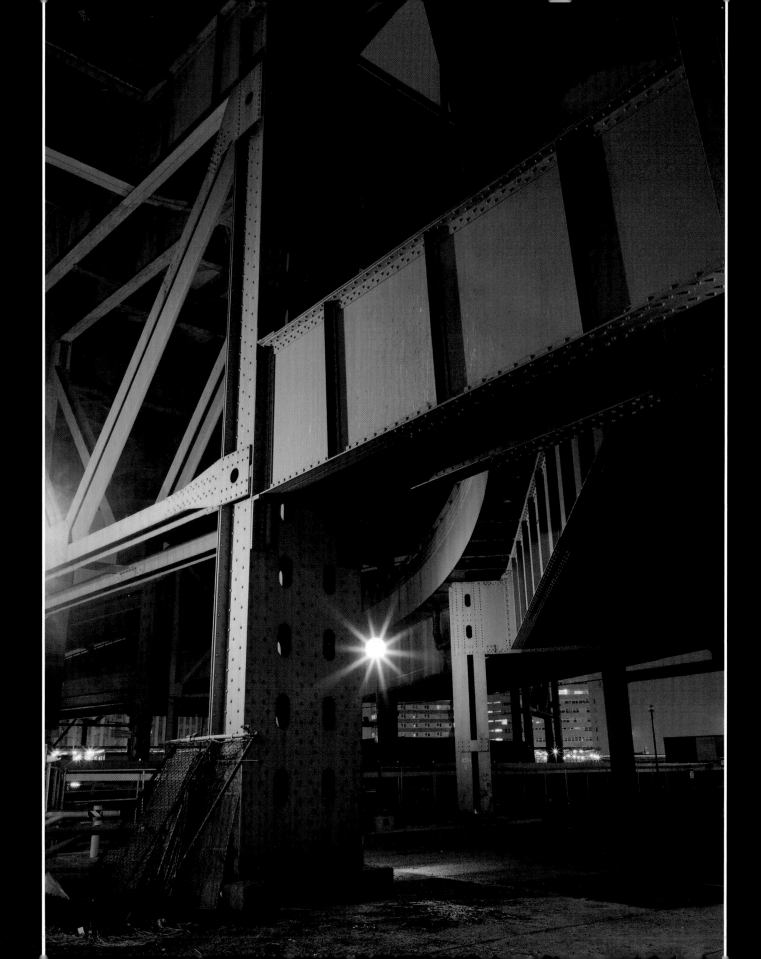

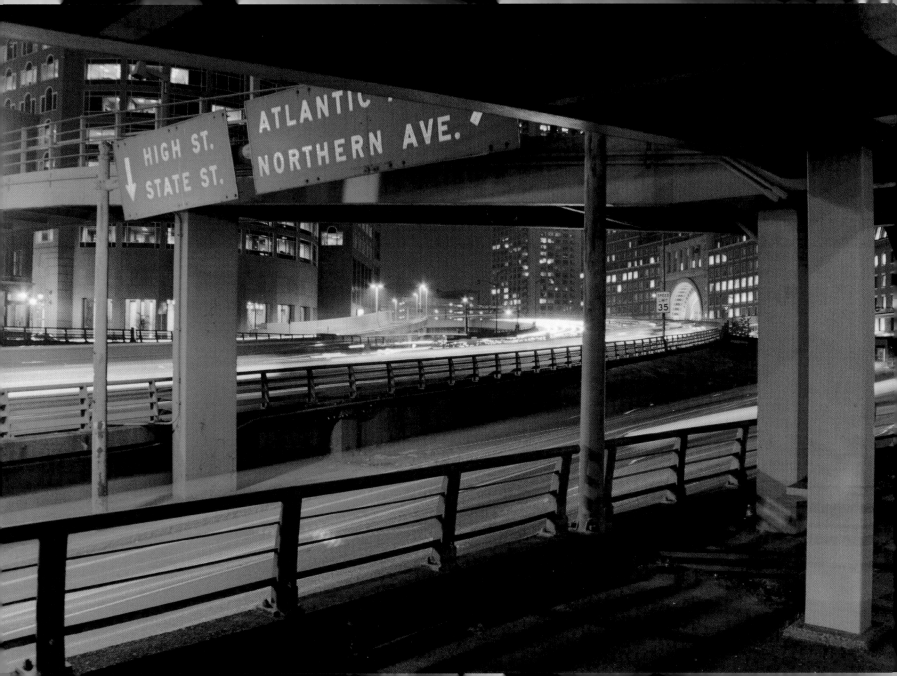

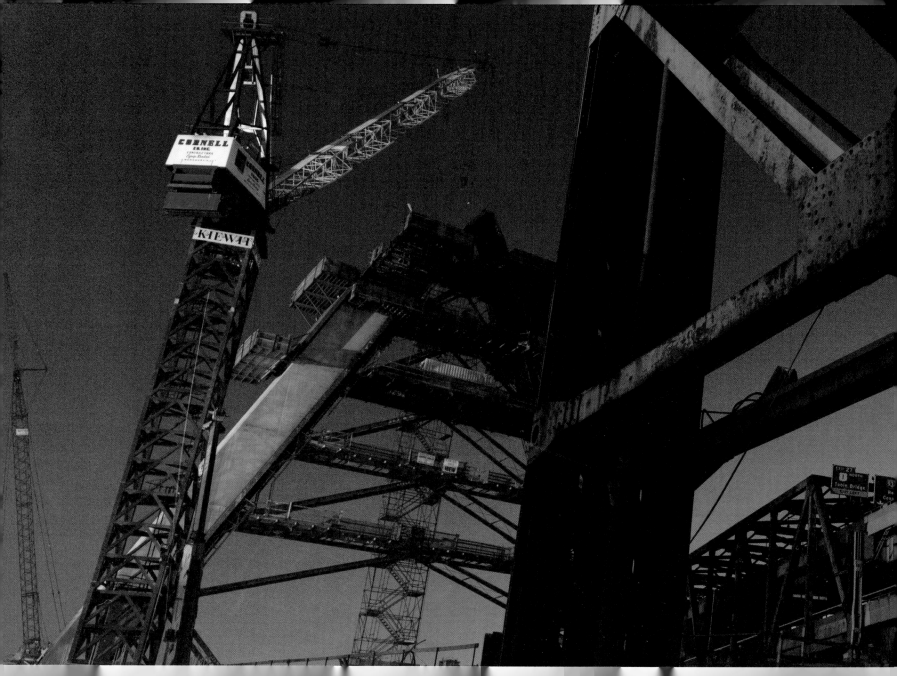

In 1808 Charles Bullfinch, America's first native-born professional architect, laid out a triangular parcel on a piece of Boston's "reclaimed land" for graceful development. In the fall of 1951 the Massachusetts Department of Public Works began destroying nearly half of Bullfinch Triangle, a national treasure, to make room for the Central Artery. The construction lights to the left sit on Causeway Street, a former Indian path.

Every column from the 1950s Skyway has been cut out from underneath it. The entire weight of the highway, I-93, and the nearly 200,000 vehicles that use it every day, rests on the rusted brown interim supports that reach down over 130 feet into the earth. The original green columns are truncated and hang precariously in midair.
Taken at 12:22 a.m., January 25, 2000.

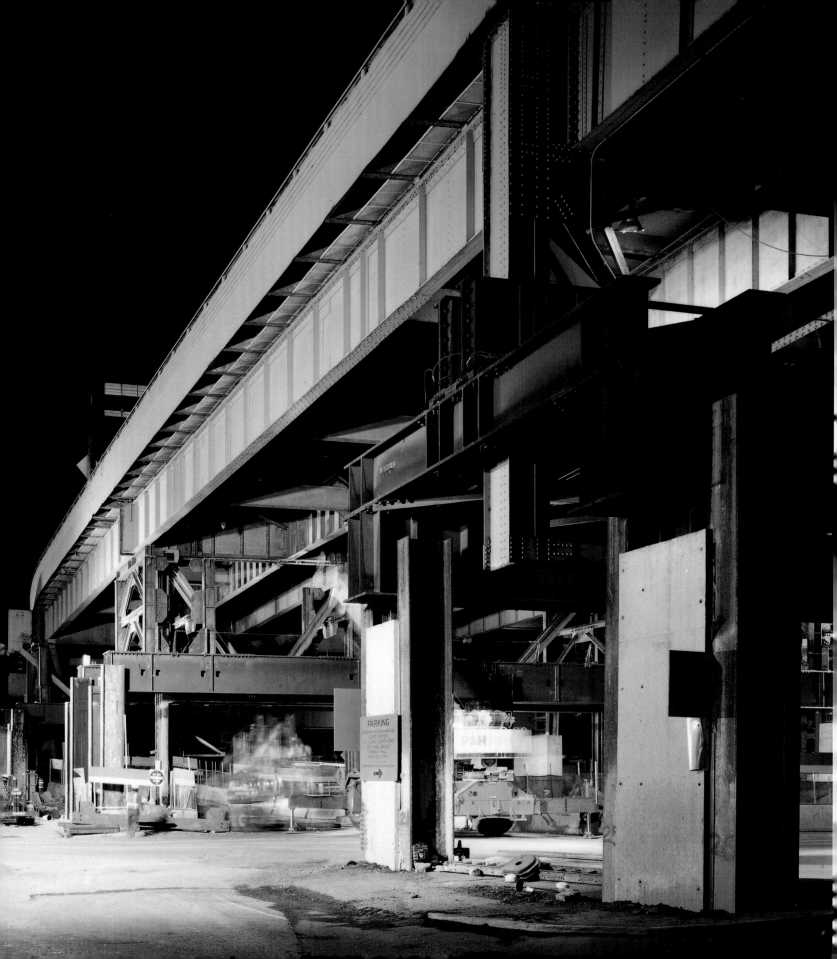

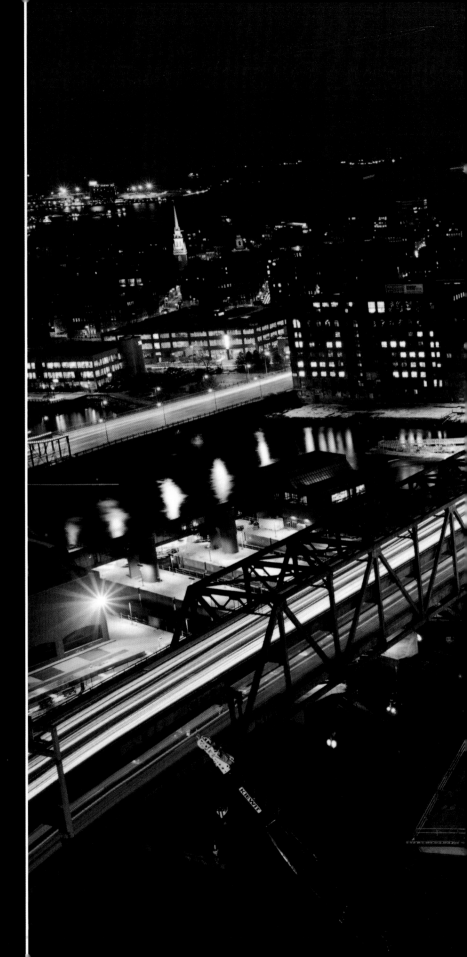

CHAPTER TWO
Building Bridges

CROSSING the Charles River will never be the same again. The dilapidated old truss bridge, known to locals as the upper and lower decks, will soon disappear. Already in place is the gently curving Storrow Drive Connector Bridge. The magnificent cable-stayed bridge, the crown jewel of the Big Dig, has dramatically transformed Boston's skyline.

4:50 p.m., February 8, 2001. The cable-stayed bridge shimmering here in the night light is officially The Leonard P. Zakim, Bunker Hill Memorial Bridge. It is the widest cable-stayed bridge in the world and is named after the famous Revolutionary War battle and the late and beloved Leonard Zakim, who tirelessly built civic bridges between Boston's communities, bringing them closer together.

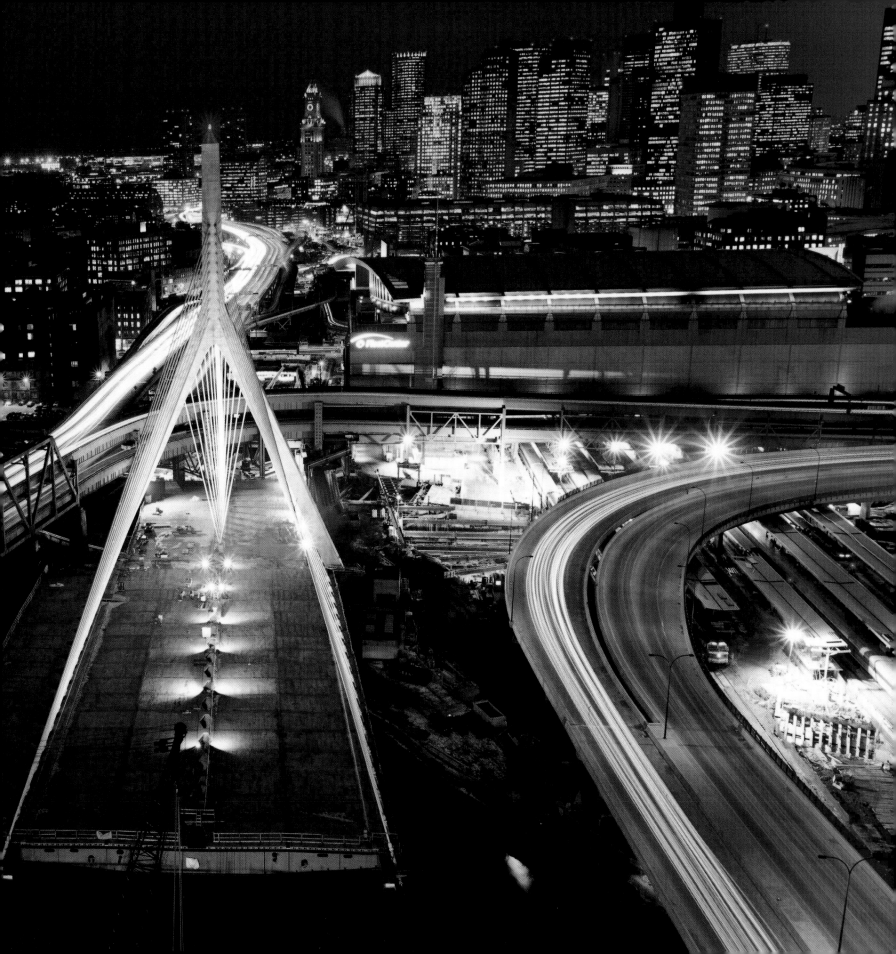

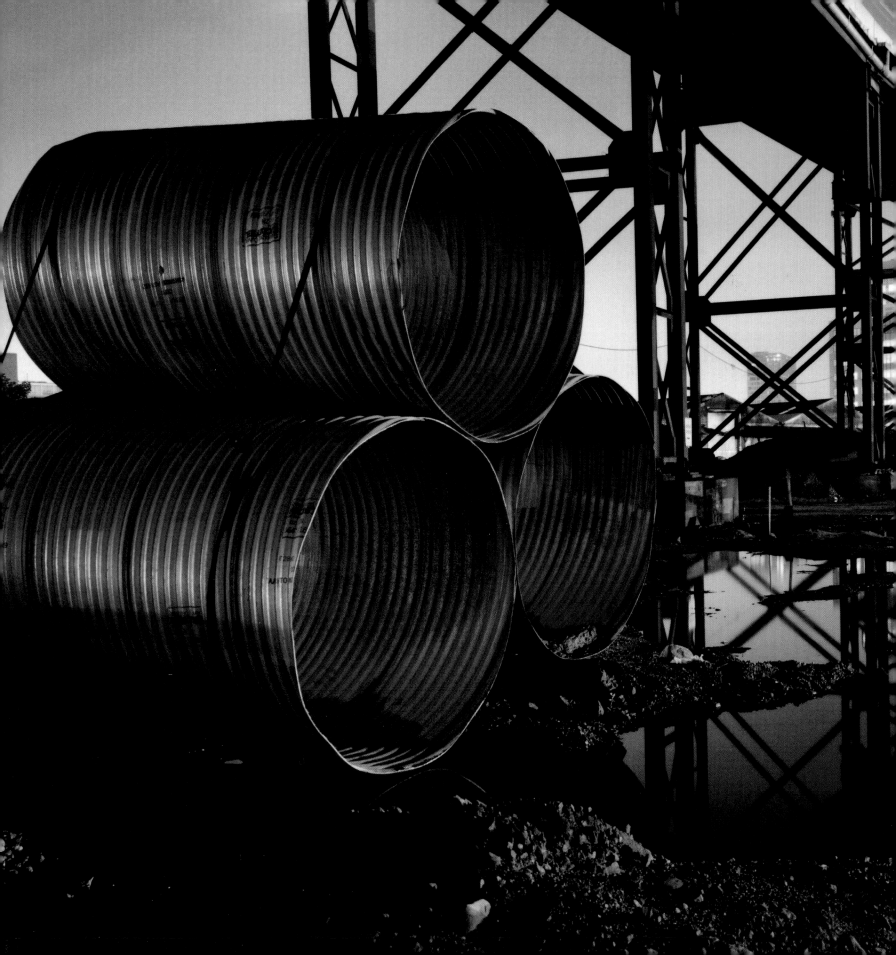

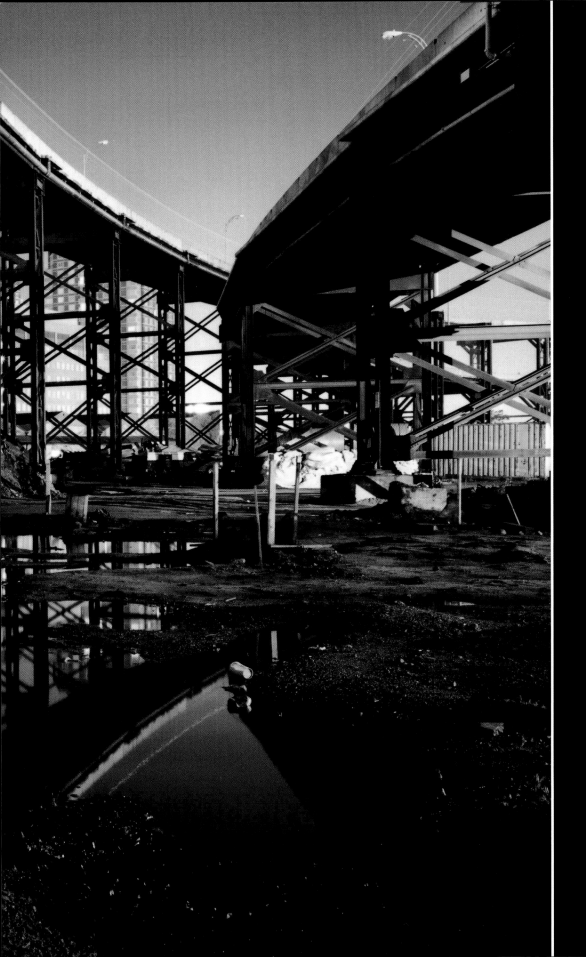

11:12 p.m., May 6, 1999.
Still water creates a double image of "temporary" bridge segments that have been carrying traffic for over seven years. These modular spans connect Boston's North Shore and Route 1 to the Central Artery (I-93). Wider permanent ramps built in this exact location will carry the same traffic over the Charles River bridges, and the modular sections will be reused. The three large pipes to the left are used to create drilled shafts that make up the foundation of the permanent bridge ramps.

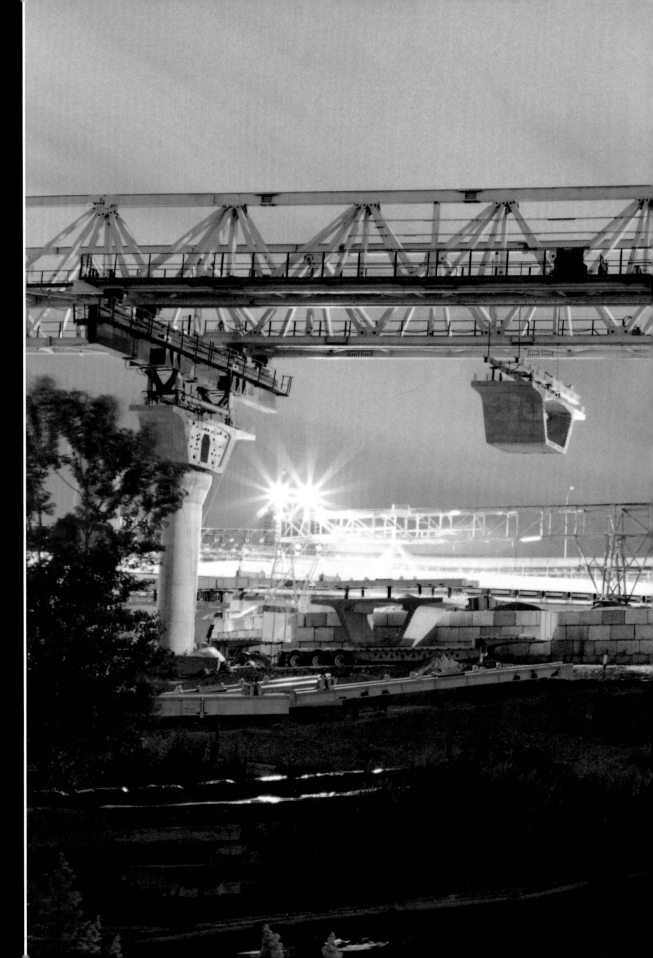

1:18 a.m., July 21, 1999. From Charlestown looking toward Cambridge. Modern Continental's self-launching gantry crane appears to be a floating 300-foot-long bridge-making factory as it labors at the Storrow Drive Connector Bridge site. While a lone prefabricated concrete viaduct section is positioned by one of the crane's trolleys, other sections below wait patiently to be lifted into place from the backs of flatbed trailers. Each concrete section weighs about 40 tons and is lifted off the trailers by the red Manitowoc crawler crane, which can lift an astonishing 250 tons (center).

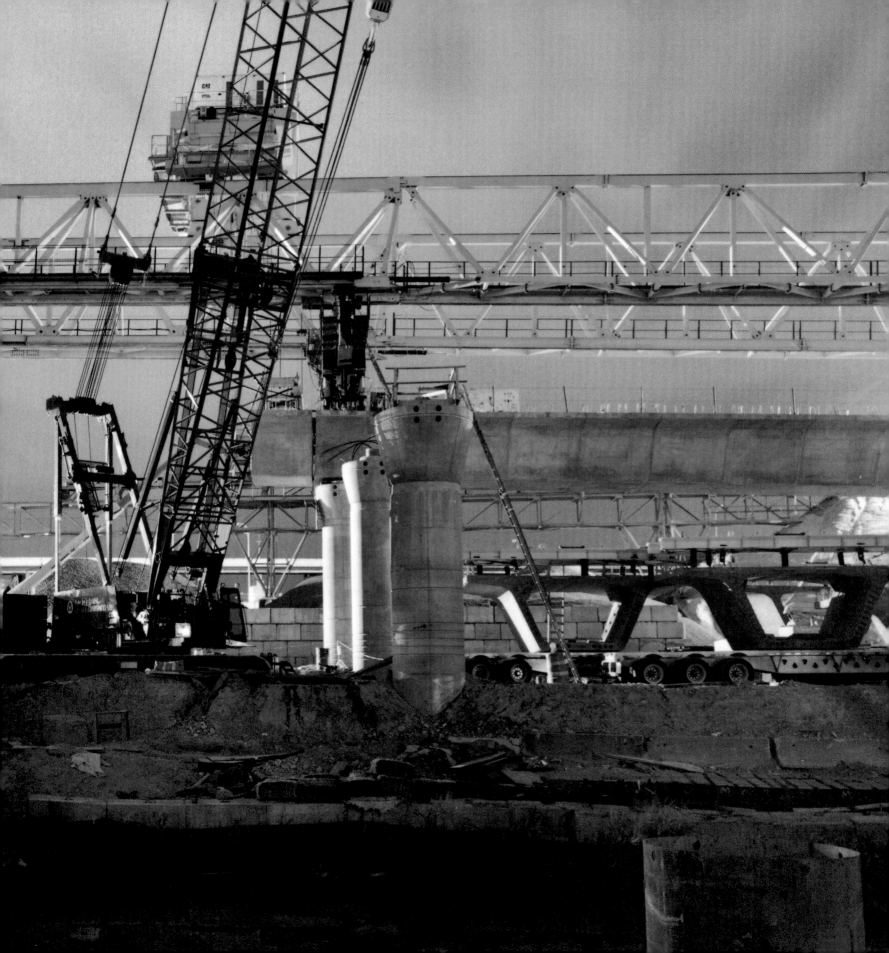

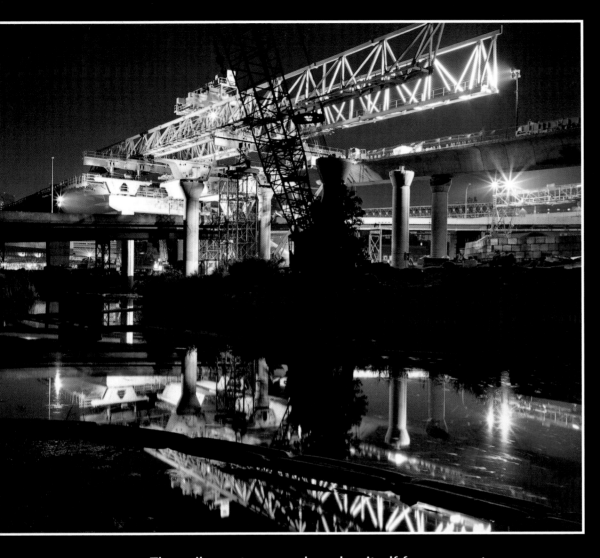

The agile gantry crane launches itself from one set of bridge piers to the next. Using the future highway columns as stepping-stones, it has the ability to move forward, backward, and sideways as it builds the roadway. Above: 12:43 a.m., June 20, 1999. The crane is reflected in the Mills River as it operates near Boston Sand & Gravel's headquarters.

Right: 1:41 a.m., October 7, 1999. A maze of ladders, landings, and observation decks allows the operators, ironworkers, laborers, and others to move about the machine and assemble the bridge below.

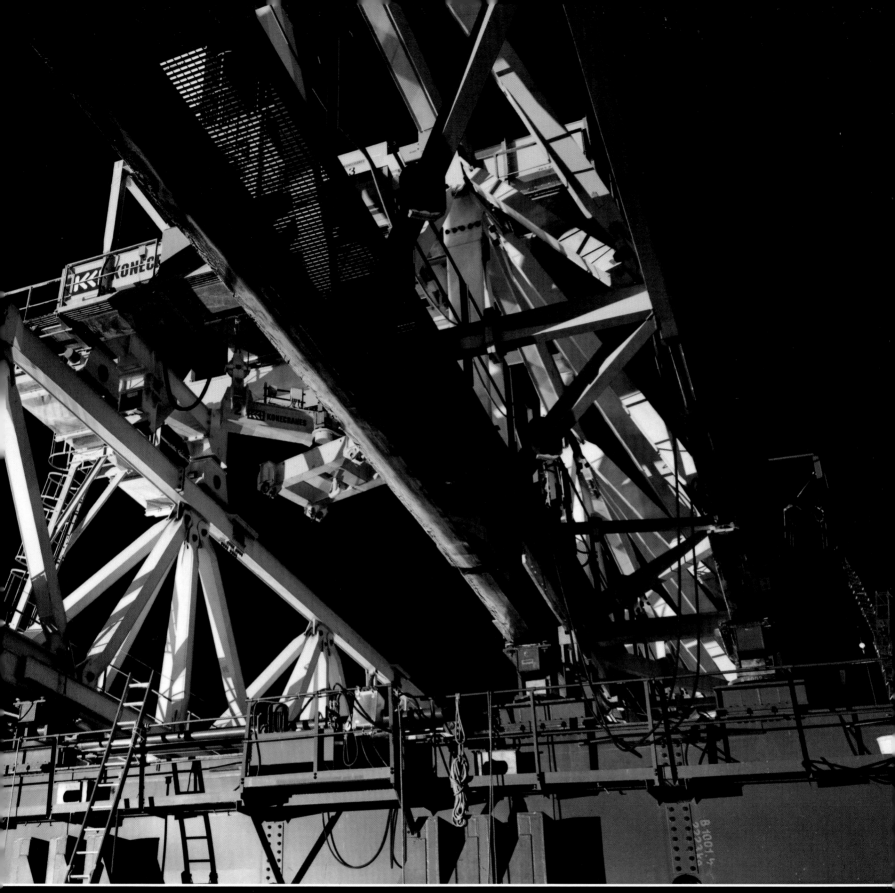

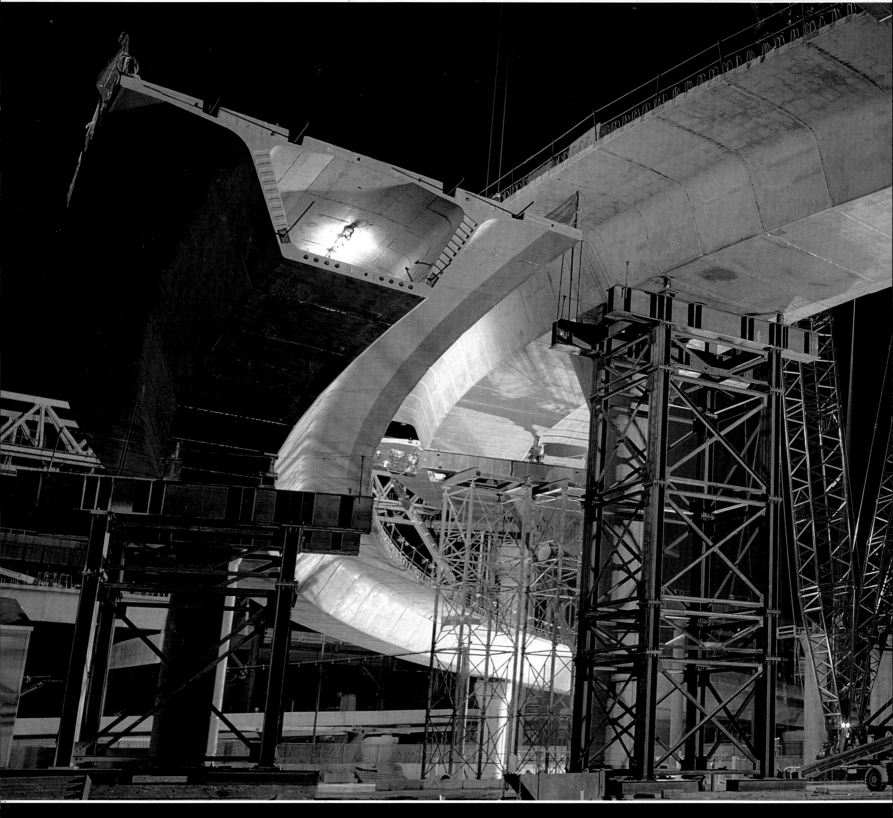

Left: 10:27 p.m., August 16, 2000. Segmental concrete viaduct sections float on temporary supports called falsework as they strain to reach the next pile that will eventually support them. Tensioning rods holding the sections together are protruding from the most recently placed sections. At this stage of construction, the bridge is enduring more stress from its own weight than it will support once it's complete. Workers are inside the section to the far upper left. Below: 1:53 a.m., October 7, 1999. The Boston Sand & Gravel complex.

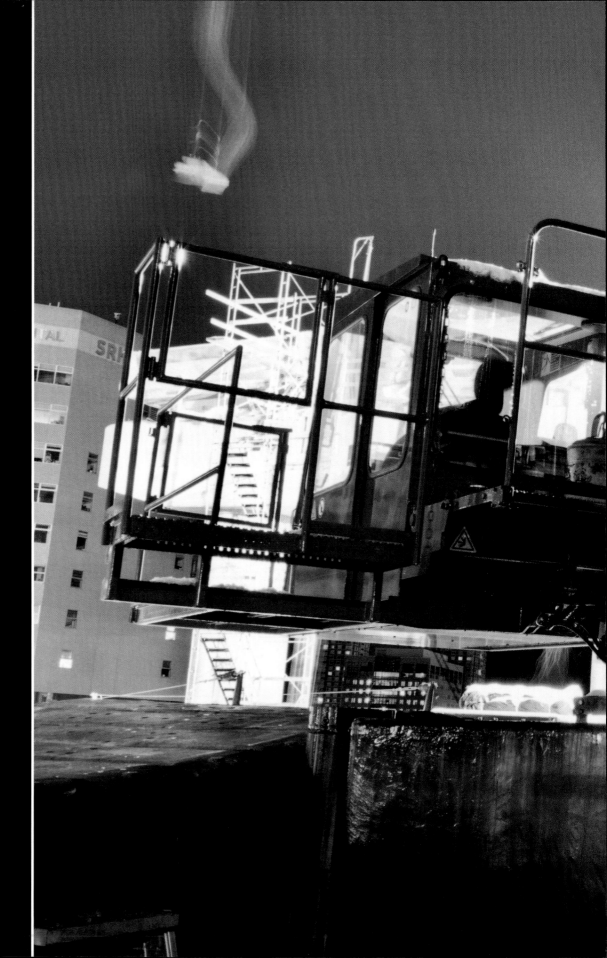

11:07 p.m., January 12, 1999. A massive 600-ton Demag tractor crane places the 150-ton tub girders of the Storrow Drive Connector Bridge over the tracks of North Station. Forty-two tractor-trailer trucks were needed to deliver the "quick-set" crane to Boston, but it took only a few work shifts to assemble it. The beams were lifted after 1:00 a.m., when Amtrak trains were no longer running and the platforms were free of commuters.

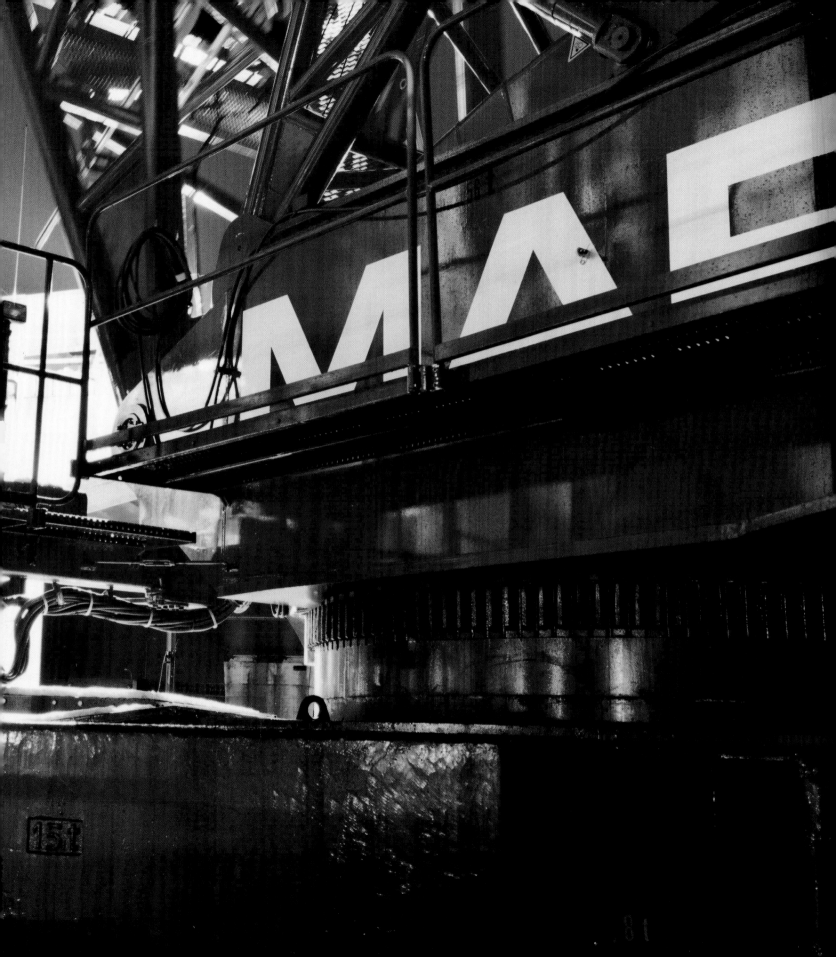

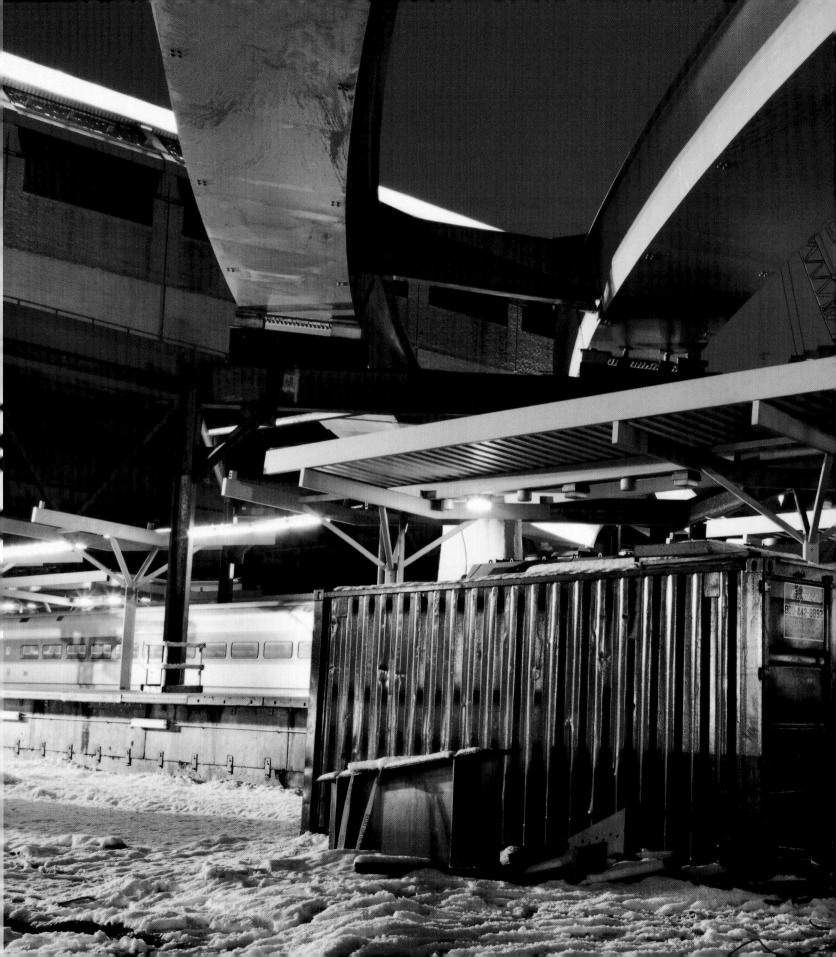

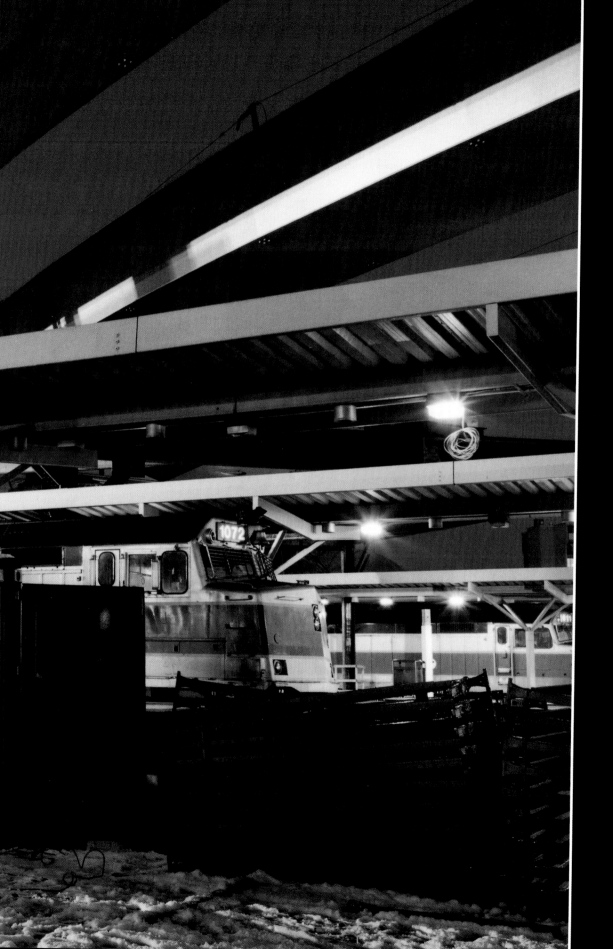

Crew shacks like the one in the bottom of this picture provide shelter for workers during extreme weather and give them a place for changing clothes and resting between shifts. Crew shacks are found throughout the eight miles of the Big Dig. The purple MBTA commuter train is pointed north, in the direction it will travel during the first run of the morning rush hour. Above the train and crew shack are 150-ton girders placed by the Demag crane. Taken the same night as the previous picture.

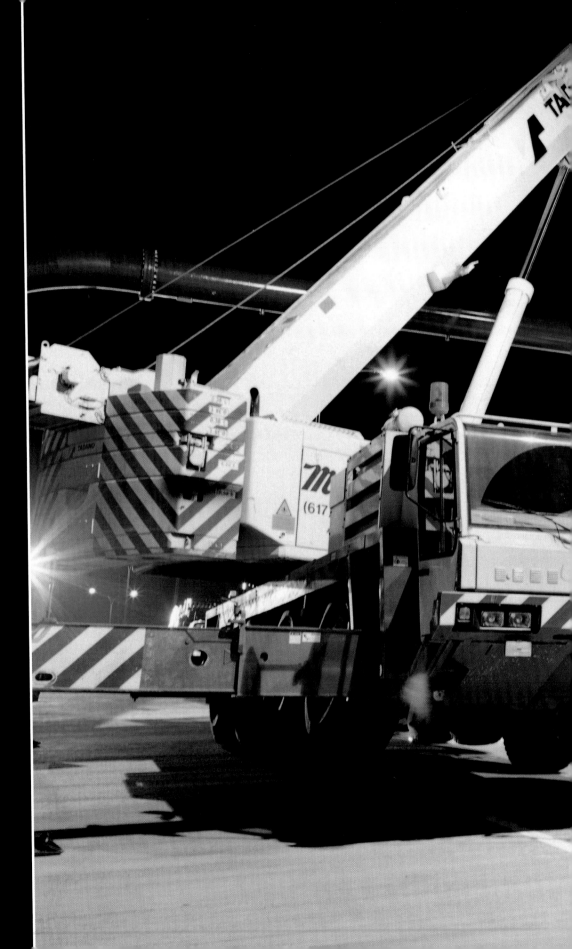

2:38 a.m., October 7, 1999.
The night before the Storrow Drive
Connector Bridge opened, an eight-
wheeled hydraulic crane places
an Interstate 93 sign for Concord,
New Hampshire. Nearly twelve hours
later, the bridge opened to traffic
that now averages over 30,000
vehicles a day. During the summer
and into the fall of 1999, local union
crews working twenty-four hours a
day, seven days a week, beat the
clock and opened the bridge a
week earlier than the date set
seven years before.

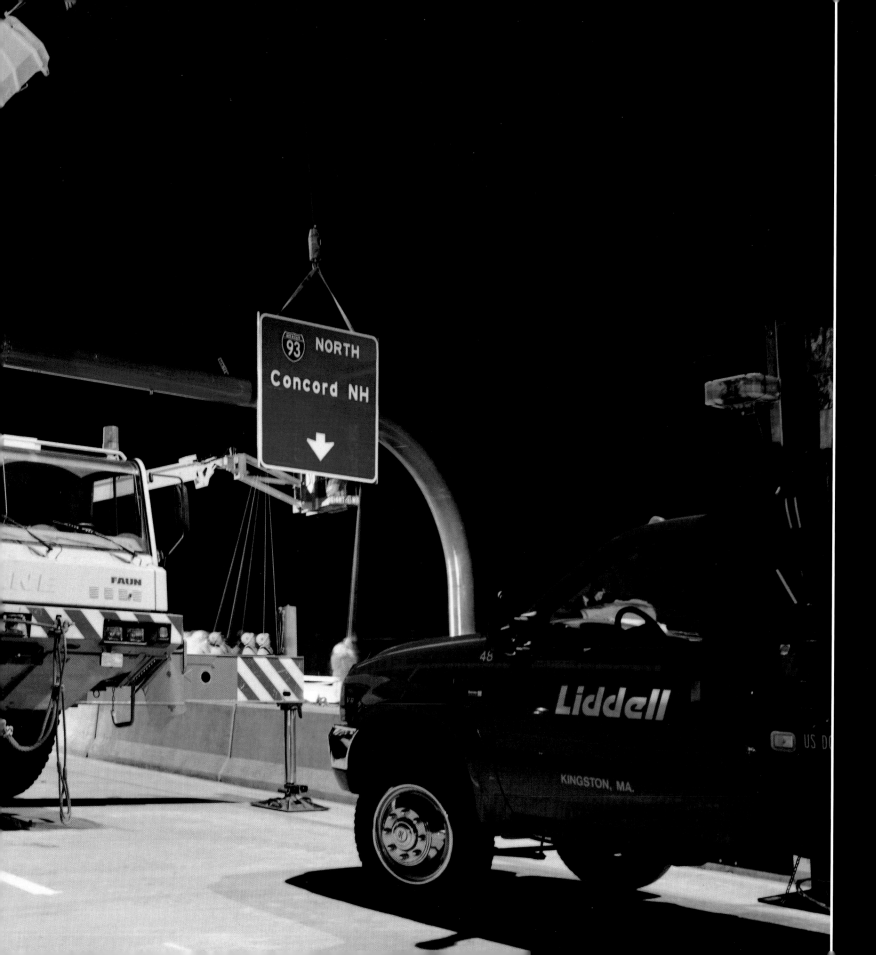

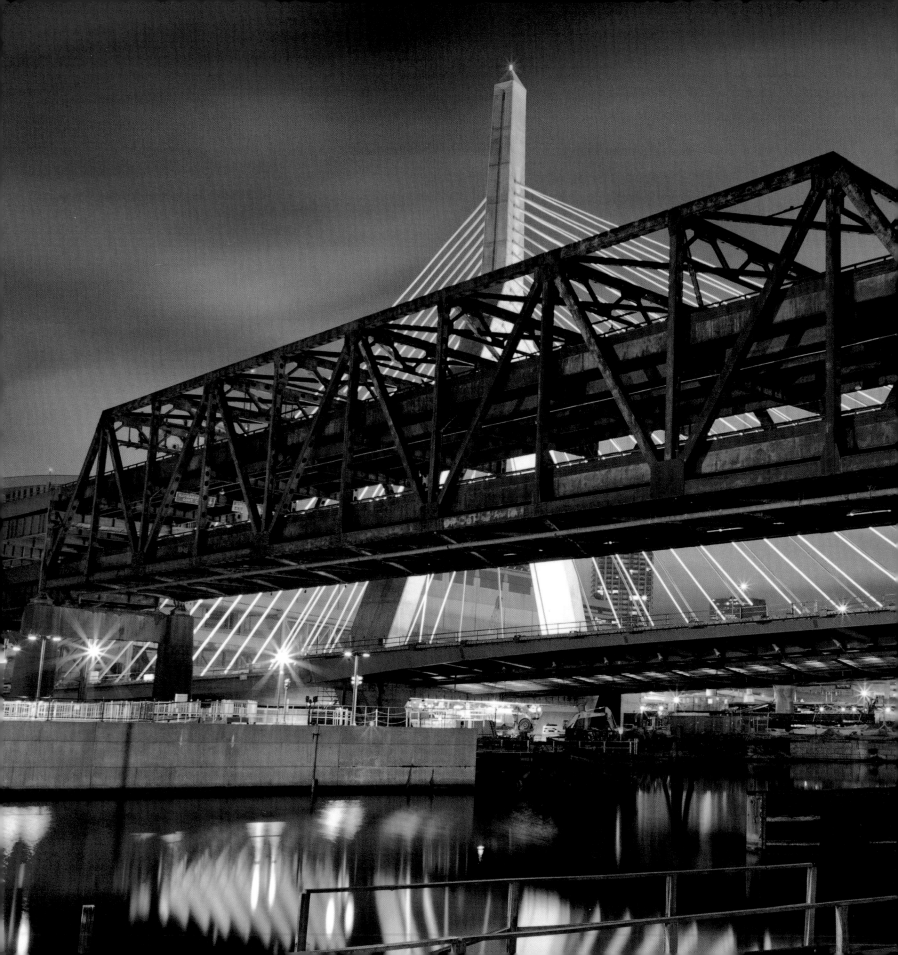

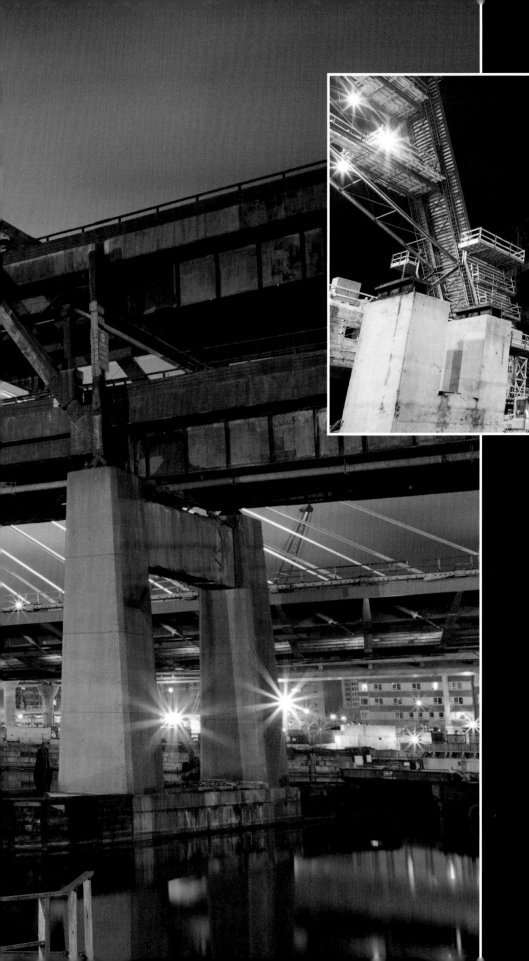

11:48 p.m., February 26, 2001.
The section of I-93 officially known
as the High Bridge is referred to by
most traffic reporters as the upper
and lower decks. Built in part by the
Berke Moore Company of Boston
between 1951 and 1954, this old
workhorse crosses the Charles River
on two concrete bridge foundations.
Its 375-foot-long double-deck main
span is barely half the length of
the cable-stayed bridge's main span,
visible in the background.

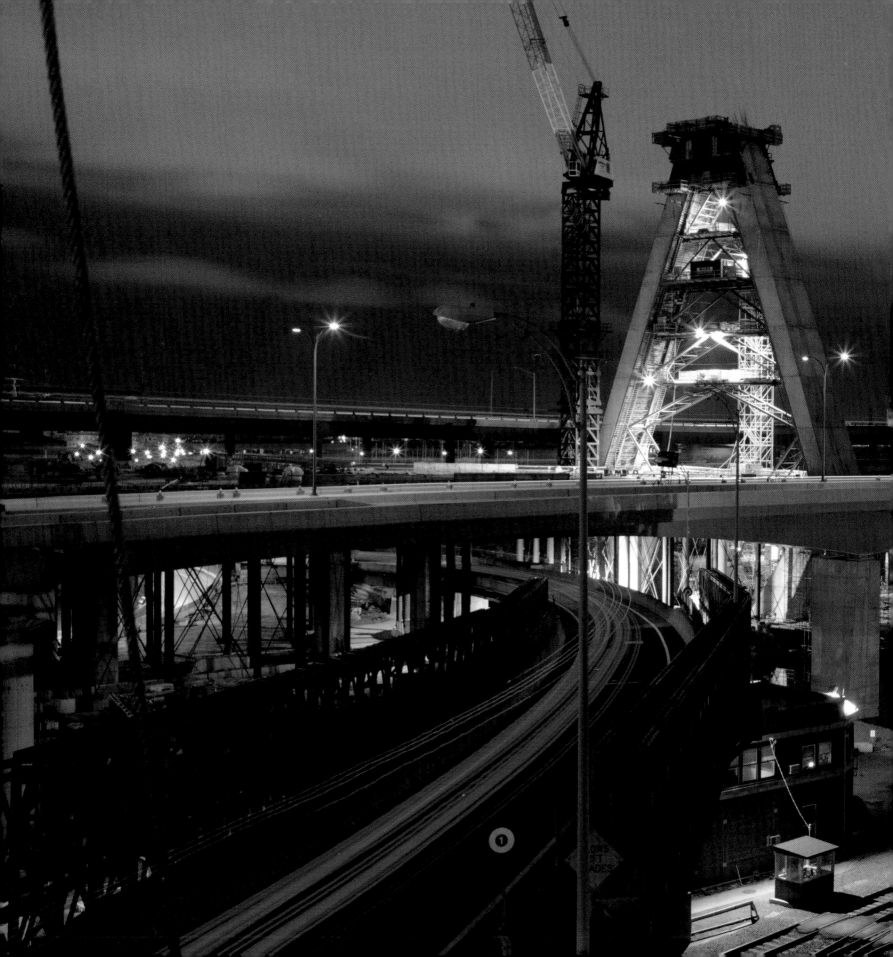

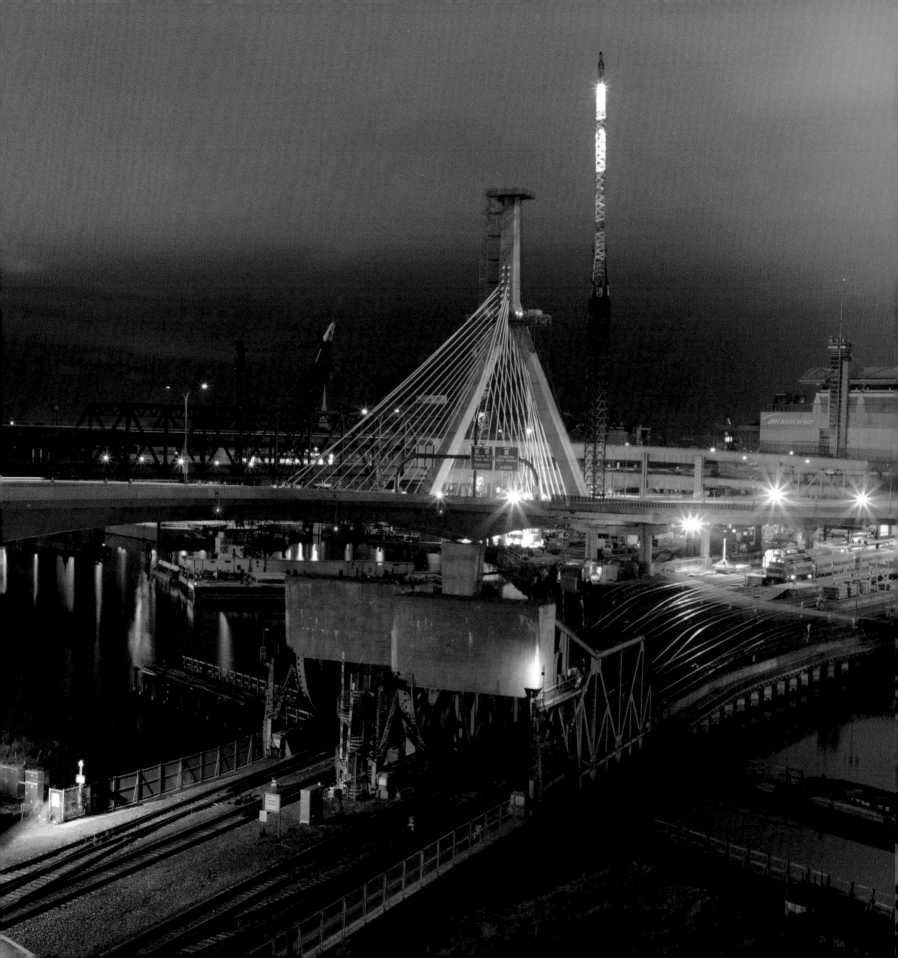

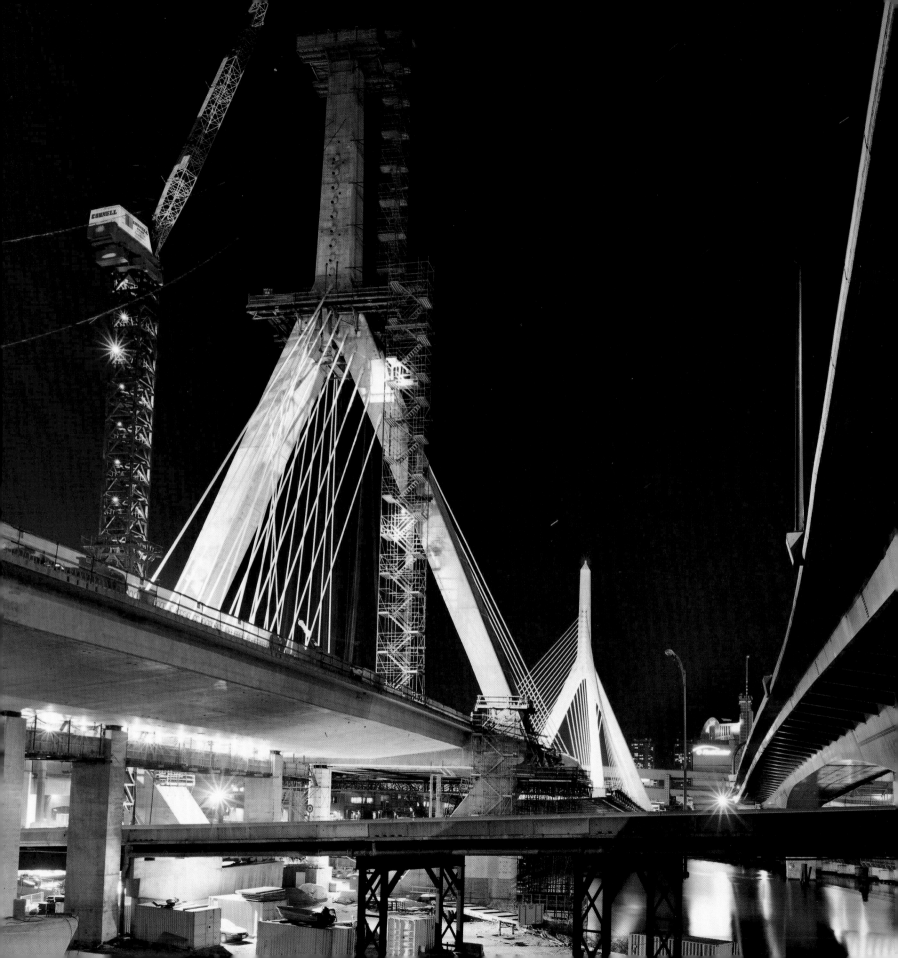

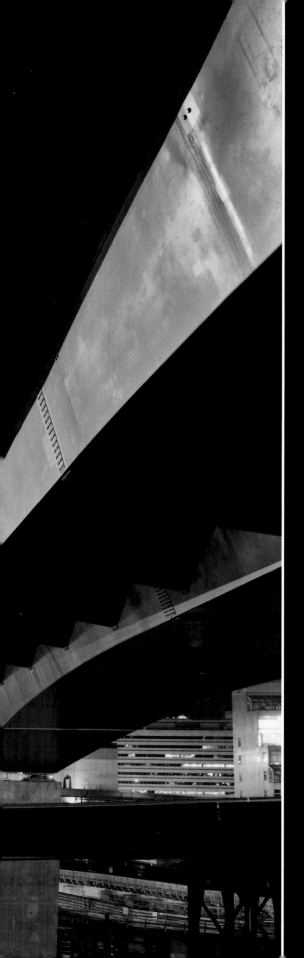

Previous page: Looking southeast toward the cable-stayed bridge with the red taillights of Route 1 traffic heading toward the Tobin Bridge. 1:17 a.m., June 22, 2000.

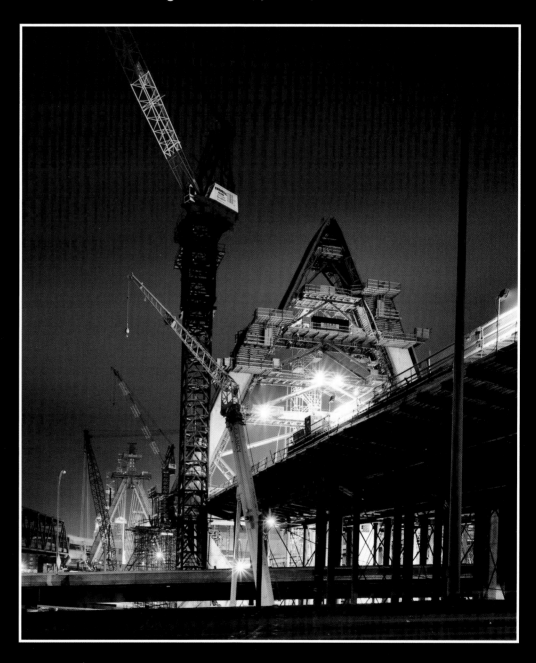

Left: 11:18 p.m., January 2, 2001. At 240 feet, the Cornell tower crane was one of the tallest freestanding tower cranes in the United States when this photo was taken. Above: A play of lights at 10:42 p.m., April 19, 2000.

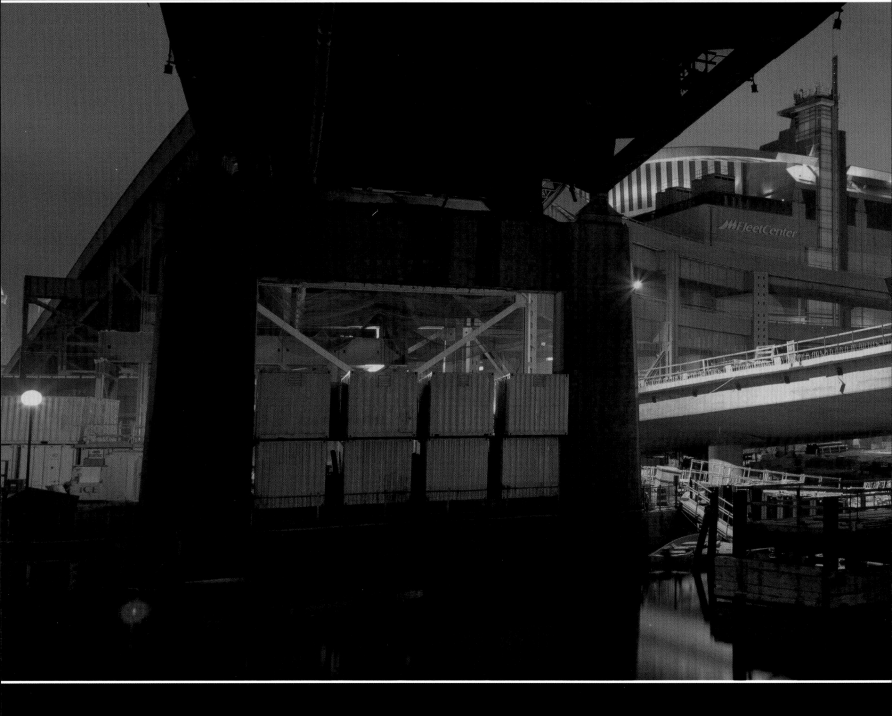

Like ships passing in the night, the new and the old meet for a brief moment in time. Kiewit's eight yellow crew shacks are nestled under the old bridge's south pier, while the cable-stayed bridge's new steel main span begins its trip across the Charles

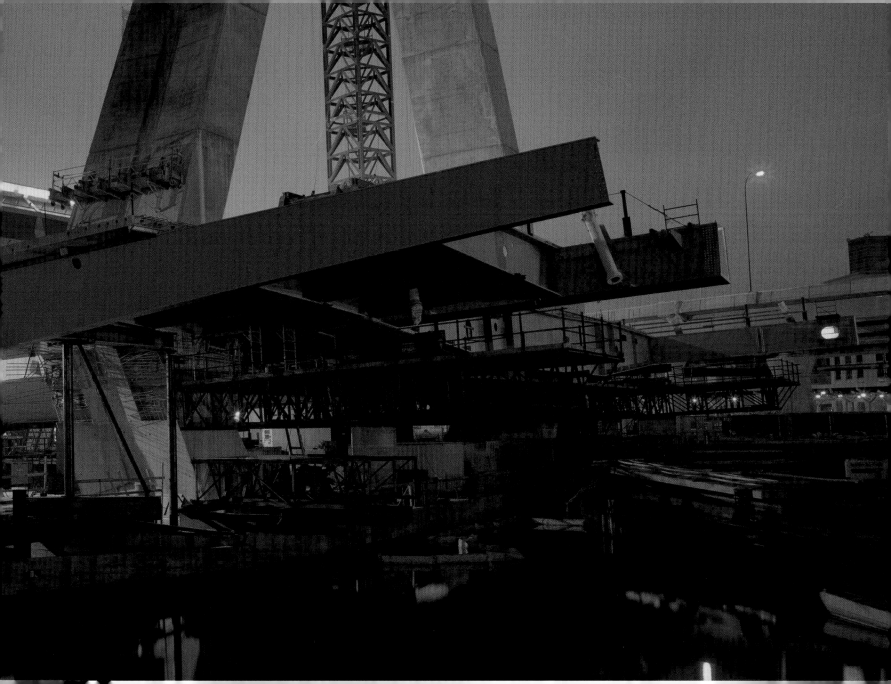

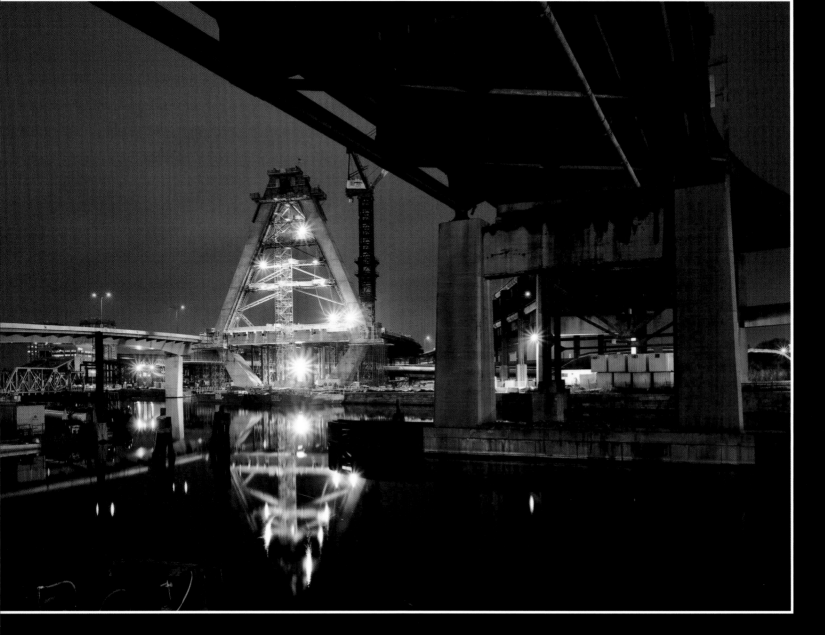

Above: 12:15 a.m., June 22, 2000. A rare nighttime concrete pour on the north tower of the cable-stayed bridge. The old bridge's concrete pier was built fifty years earlier, and both old and new are made with Boston Sand & Gravel's concrete.

Right: 11:33 p.m., February 26, 2001. The north tower is nearly complete, with a topping-off flag and platform at the 330-foot level. The steel main span is held to the south and north towers by the white cable stays. This picture was taken just before the last girders were placed to make the main span one continuous bridge deck,

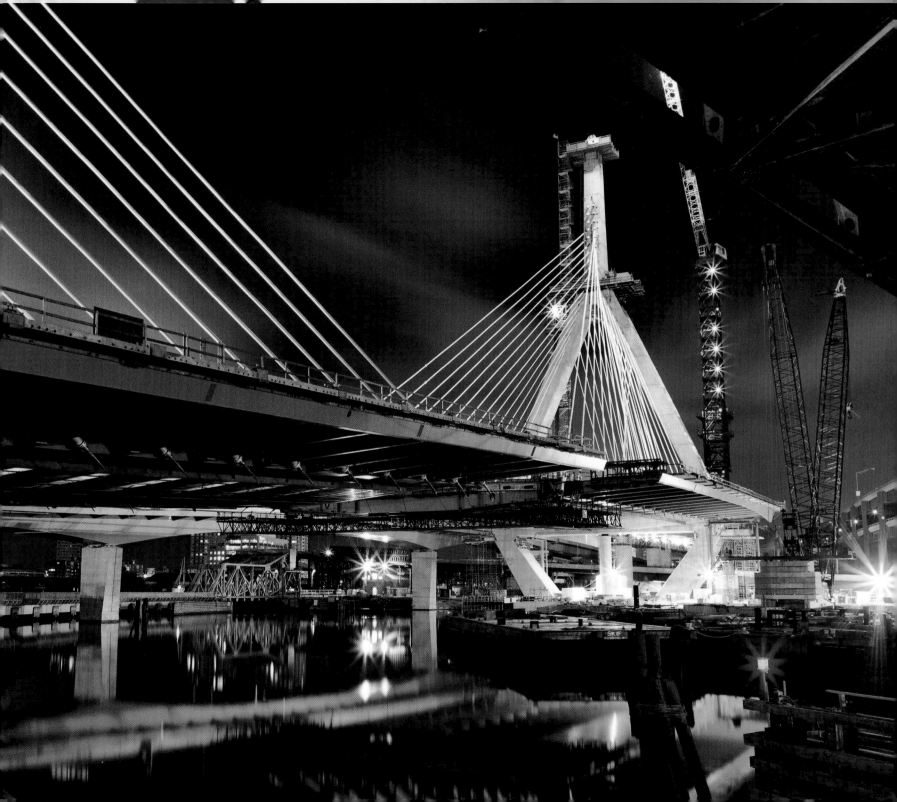

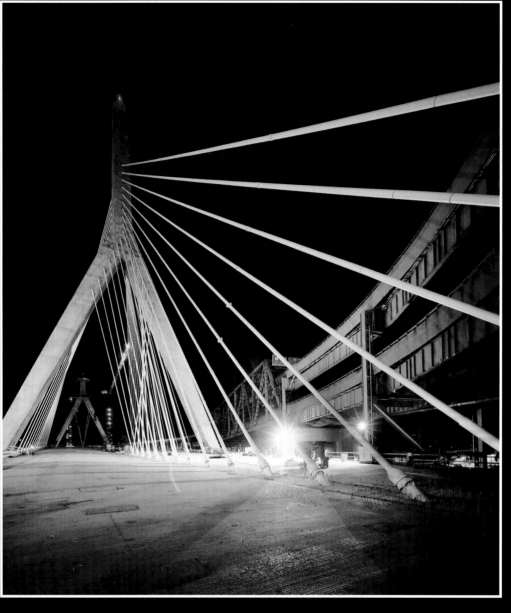

9:51 p.m. and 10:18 p.m., October 16, 2000. In the night light, the old truss bridge of I-93 is just a ghost in the background as the illuminated cable stays steal the show. Above: From the south tower's back span looking north. Right: During the night, crews experiment with the lighting of the bridge towers and cable stays, providing this spectacular display. When the bridge is complete, the diamond-shaped openings in the foreground will bring light to fishermen, boaters, bikers, bladers, and pedestrians in a new 44-acre park beneath the superstructure.

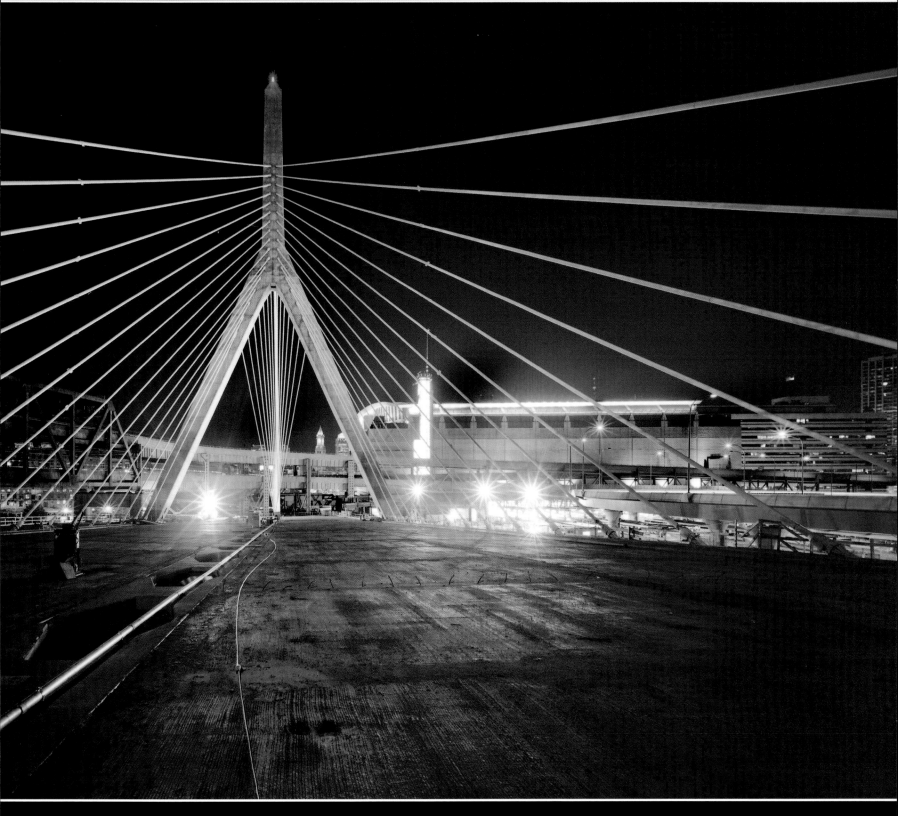

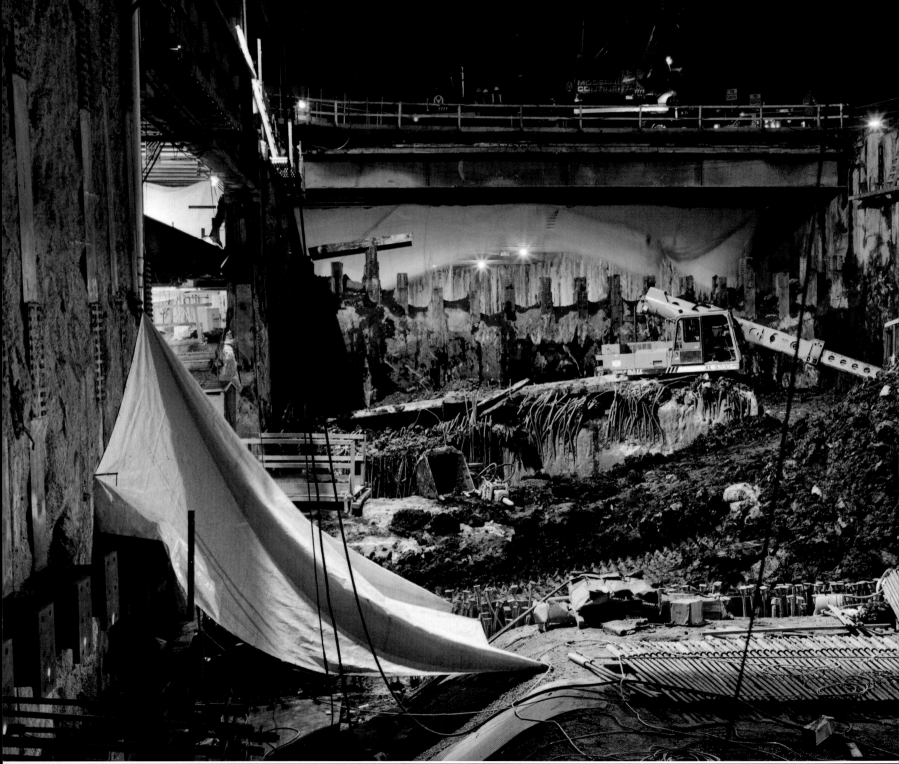

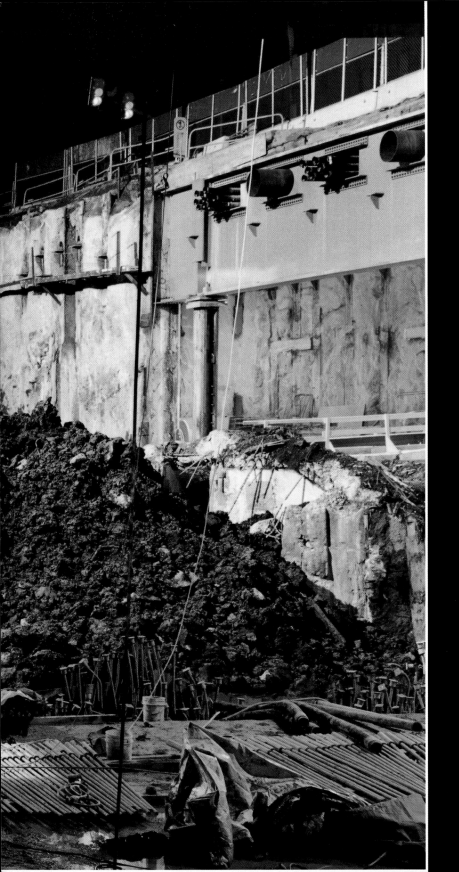

Under the Elevated

TRAFFIC ON the old Skyway barely moves while massive construction takes place underneath, twenty-four hours a day. Once the tunnel is complete, the 200,000 cars and trucks that daily choke the Skyway will travel efficiently below the city, unseen and unheard.

Beneath the old elevated highway, an enormous tunnel is under construction. Here, mud and dirt are piled high between the future highway tunnel walls, called slurry walls, which hold back the earth and hold up the highway. An excavator sits above the Blue Line subway, built in 1904, which runs through the floor of the site from left to right. In the background, orange lights from workers placing tiles and other tunnel finishes can be seen. 11:21 p.m., March 29, 2000.

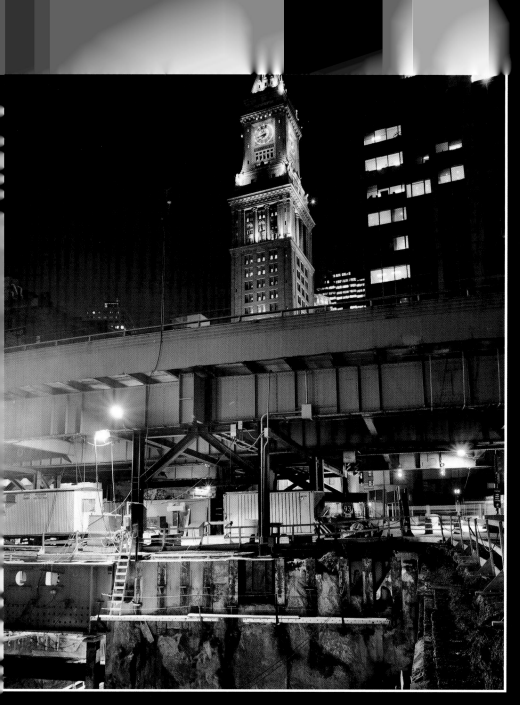

Above: 10:56 p.m., March 29, 2000. The Custom House
Tower watches over the Big Dig at night. Slurry walls and
interim supports hold up the elevated highway. A wooden
walkway on top of the Blue Line is at the lower left.

Right: 1:24 a.m., January 25, 2000. The elevated highway's entire
set of legs has been cut out from beneath it, and the original
supports are left hanging like the one to the middle left.

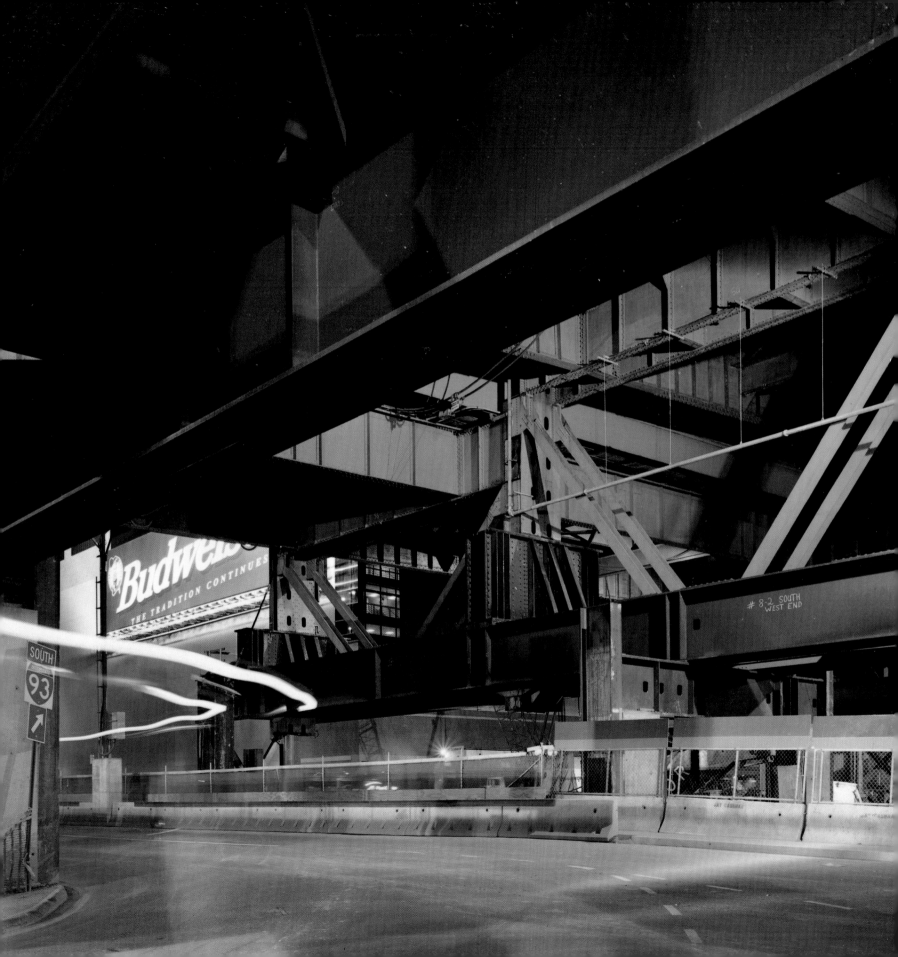

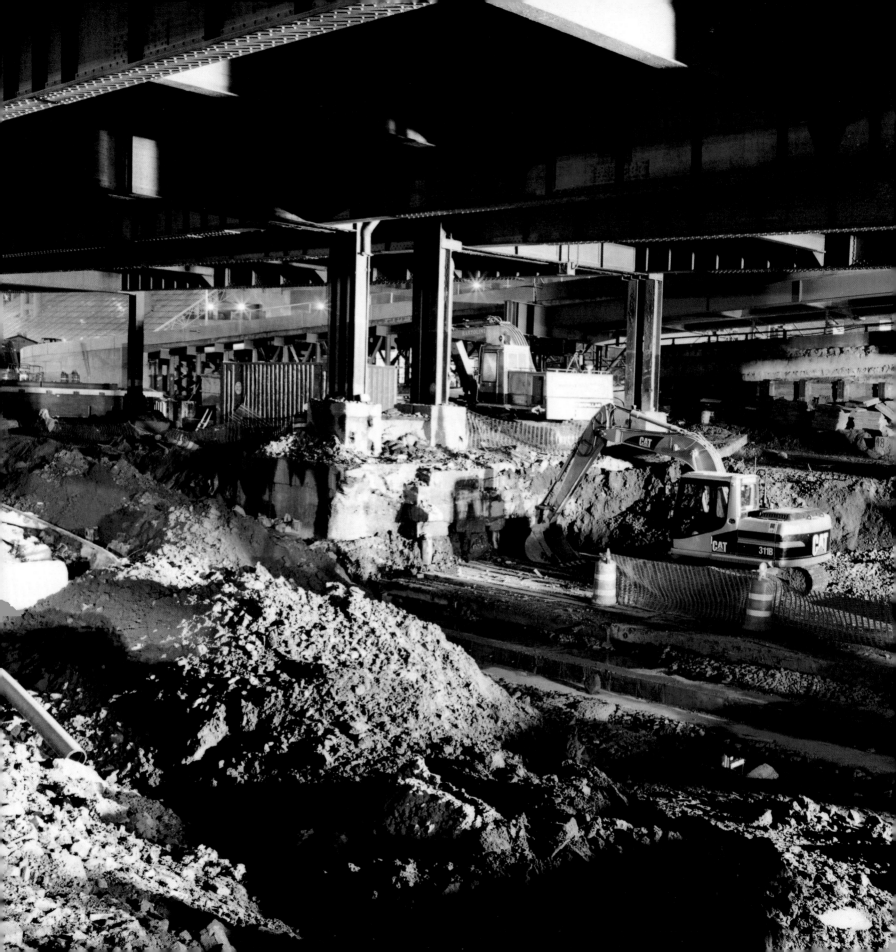

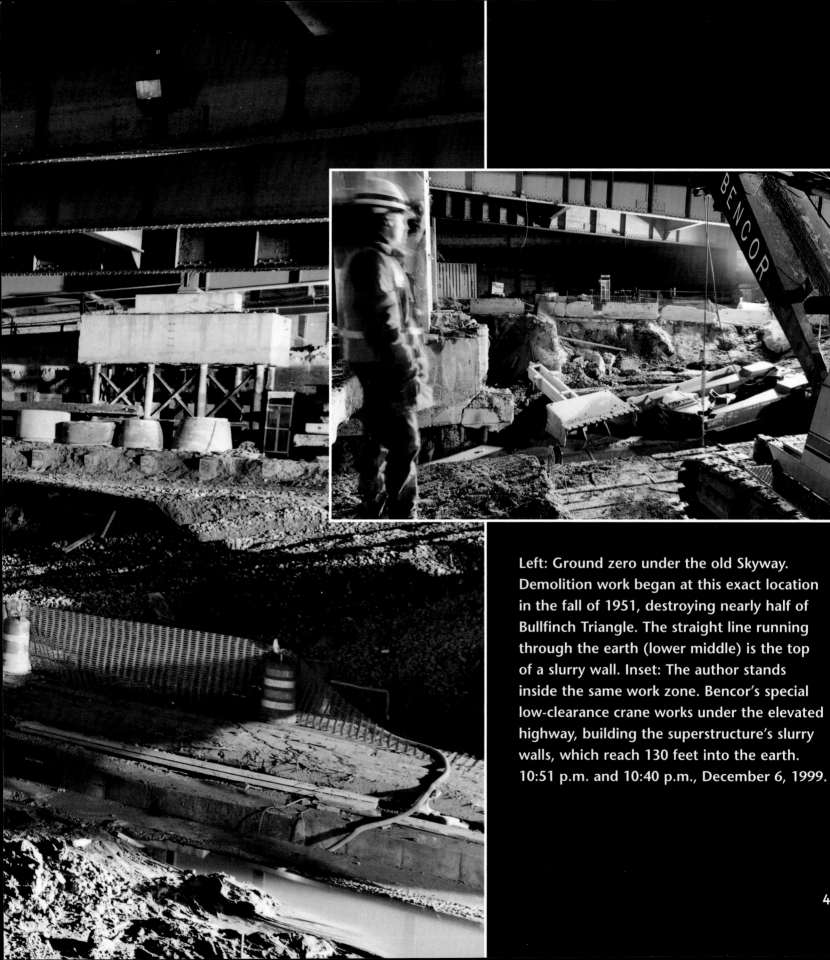

Left: Ground zero under the old Skyway. Demolition work began at this exact location in the fall of 1951, destroying nearly half of Bullfinch Triangle. The straight line running through the earth (lower middle) is the top of a slurry wall. Inset: The author stands inside the same work zone. Bencor's special low-clearance crane works under the elevated highway, building the superstructure's slurry walls, which reach 130 feet into the earth. 10:51 p.m. and 10:40 p.m., December 6, 1999.

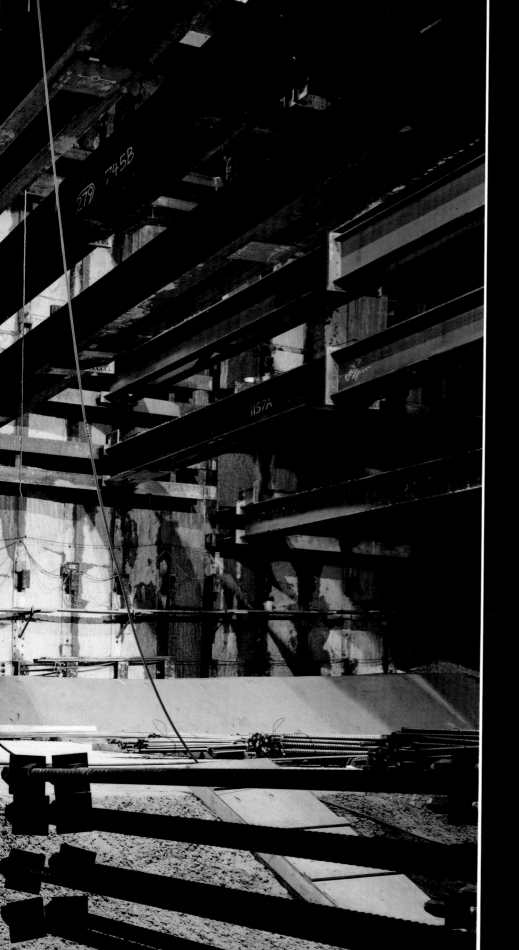

The skeleton of a superhighway tunnel deep under the Old North End. The heavy-duty forklift is facing the future northbound traffic, and the massive cross-lot struts running above it weigh over 40 tons each. The struts force up to 900 tons of pressure on the slurry walls so they remain still. The struts are fastened to walers that are attached to the soldier piles in this picture. Soldier piles are placed about every five feet along the Big Dig's five miles of downtown slurry walls. Running to depths of 130 feet, the soldier piles give the slurry walls strength. These walls, in turn, hold up the old Skyway, support historical structures and skyscrapers, and finally become the finished walls of the highway. Taken at 9:50 p.m., October 12, 2000.

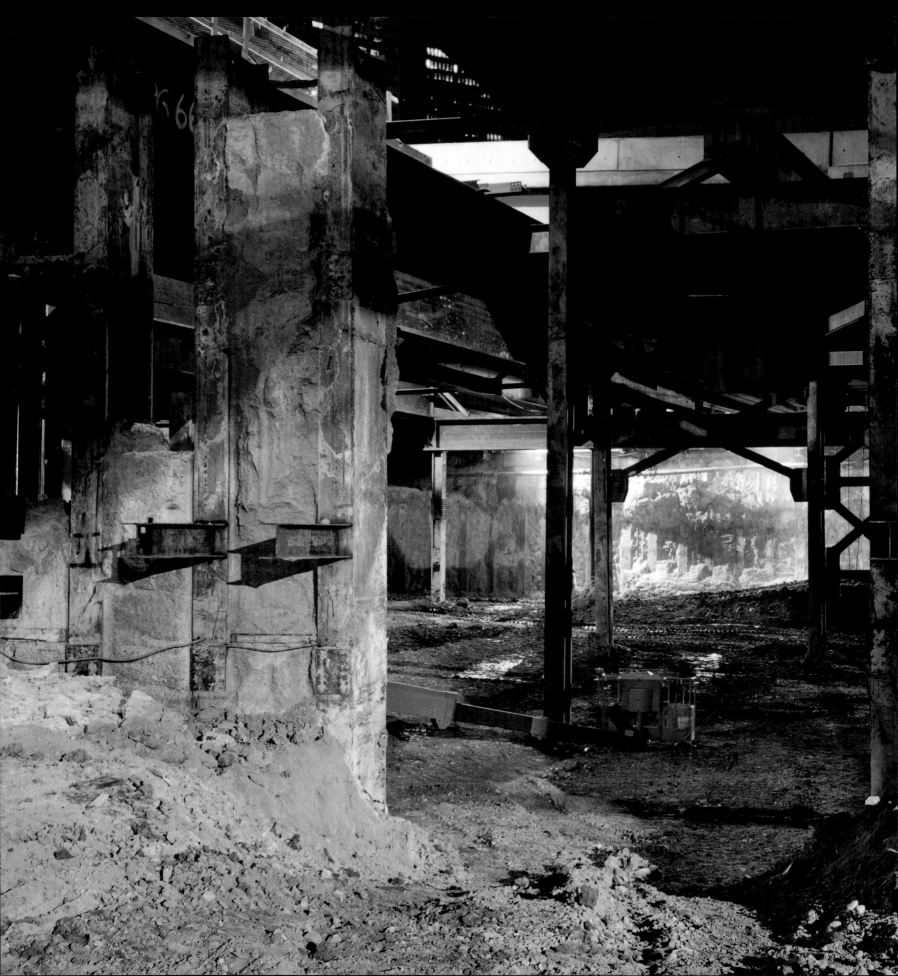

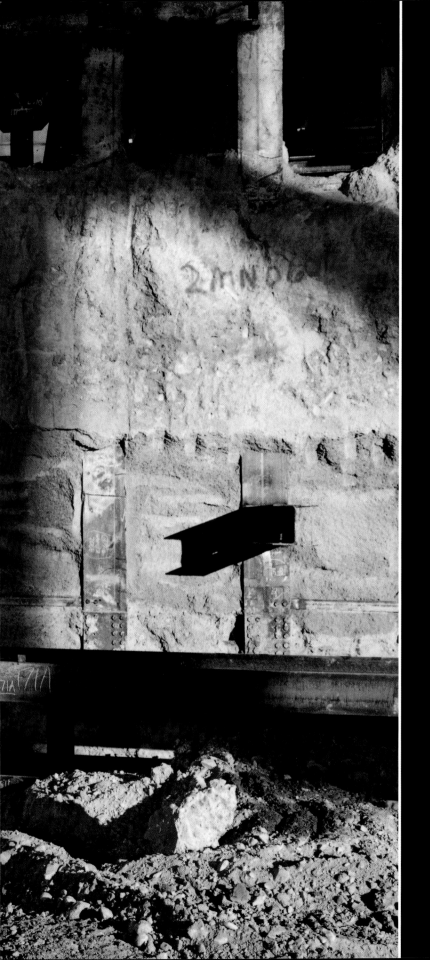

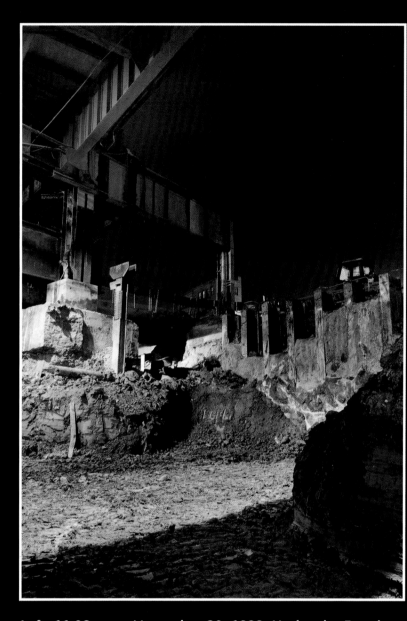

Left: 11:09 p.m., November 30, 1999. Under the Freedom Trail in the North End. The photo shows a gap created by the removal of a column from the 1950s that supported the old elevated highway directly above. Breaks like this one occurred when the slurry walls were constructed around the original supports of the Skyway. Construction workers and equipment used them as passageways before they were filled in. Above: 11:47 p.m., January 19, 2000. An old support still holding up the elevated highway near Cross Street in the North End.

53

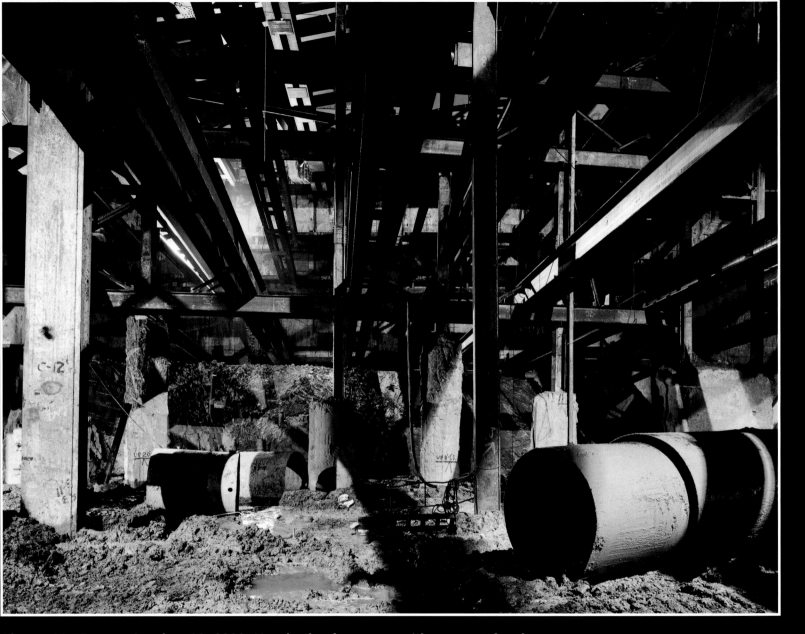

Above: 10:55 p.m., October 12, 2000. Hundreds of struts provide support for the widest section of the Big Dig's tunnels under Haymarket Square. SetteDucati calls this J. F. White's Steel Forest in honor of the lead contractor on this tunnel section.

Right: 7:17 p.m., December 7, 2000. With their backs to a slurry wall, a Local 4 operator and one of the largest excavators of its type take a break from digging around the base of a pin pile holding up the busy street above. Massive banks of lights make it seem like daylight underground.

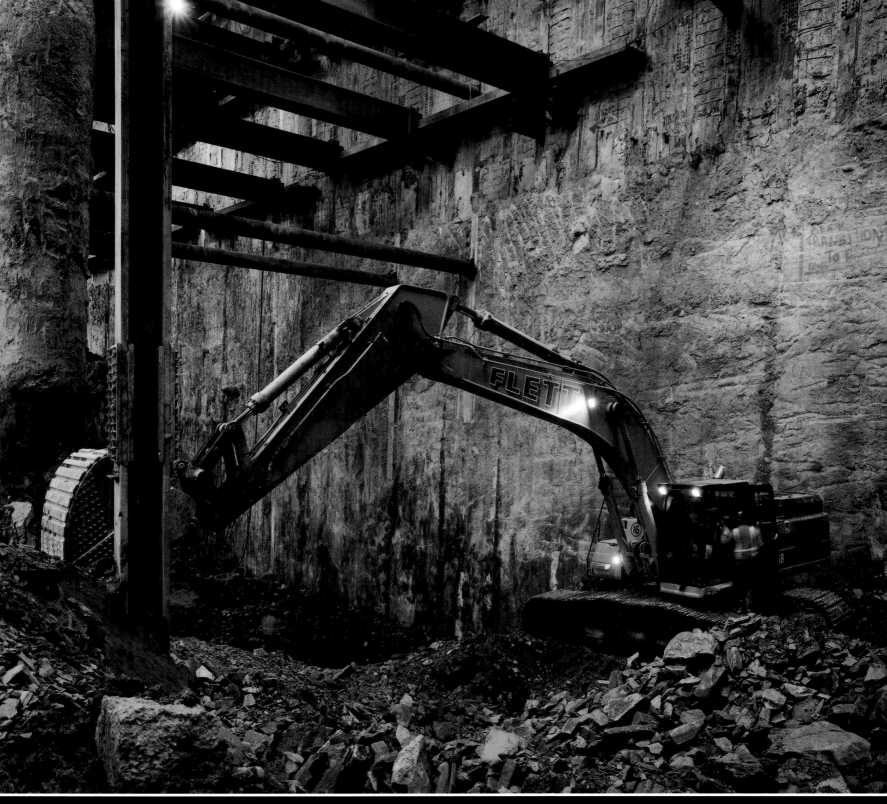

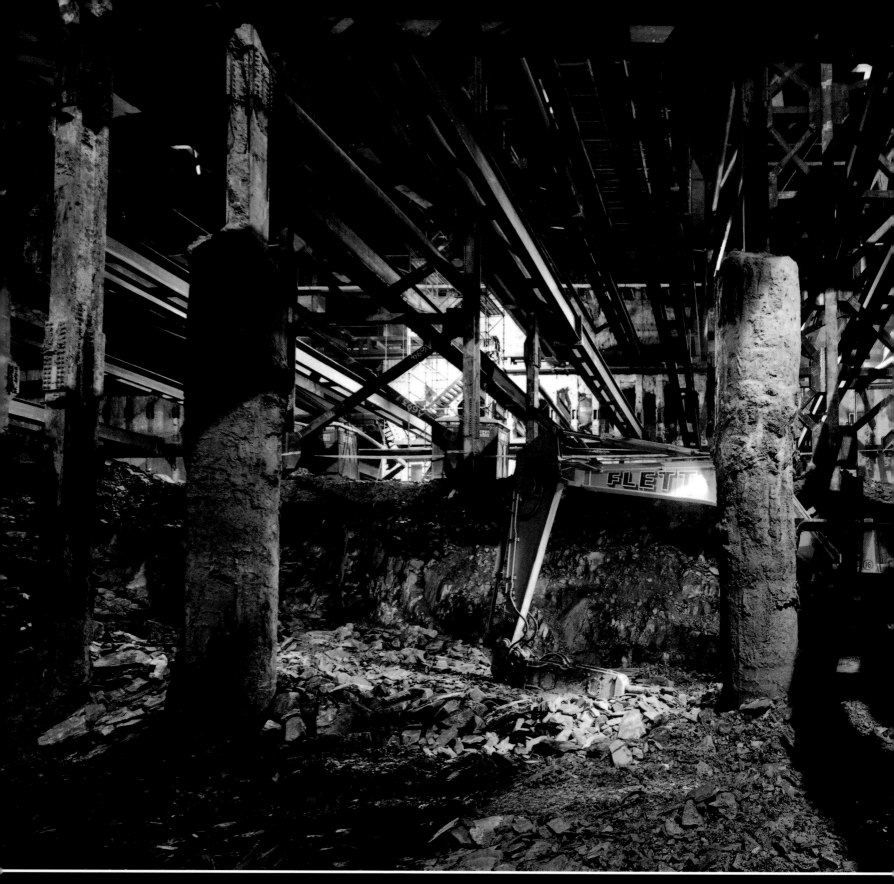

Left. 8:43 p.m., December 7, 2000. Vertical pin piles hold up thousands of the concrete deck panels that the Big Dig uses to keep surface roads open. Other vertical supports directly behind the excavator help hold up eight lanes of the elevated highway under Haymarket Square.

Below: A 200-ton German Liebherr tractor crane pulls out the earth from the same construction site. The underpinning system to the left of the crane helps to hold up the widest section of the elevated highway. 11:01 p.m., October 12, 2000.

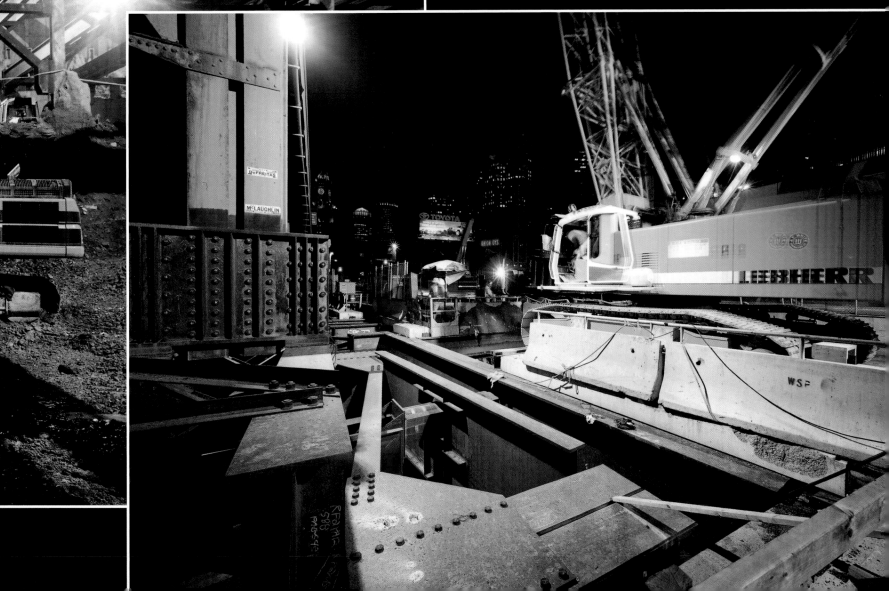

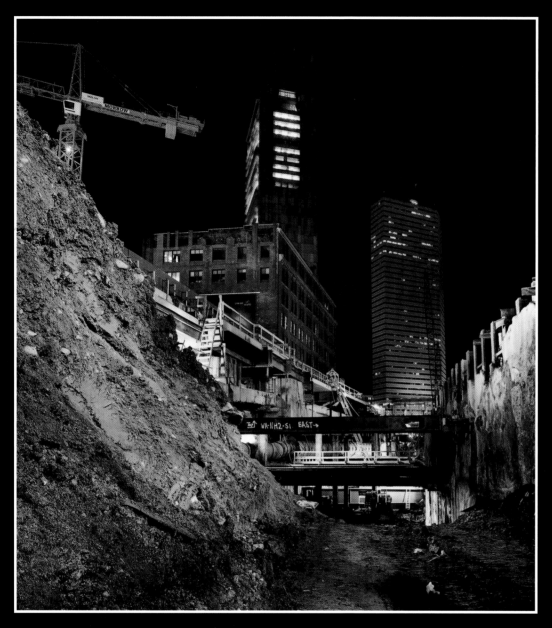

Above: 11:23 p.m., November 14, 2000. The Federal Reserve Bank and One Financial Center tower over the edge of a Big Dig abyss. To the left, a yellow tower crane constructs an enormous ventilation building, part of the largest ventilation system in the world. To the right is a slurry wall for the future I-93 northbound tunnel.

Right: The same evening in a tunnel beneath live utility lines, Local 7 ironworkers prepare the surface of a slurry wall for the placement of the giant struts.

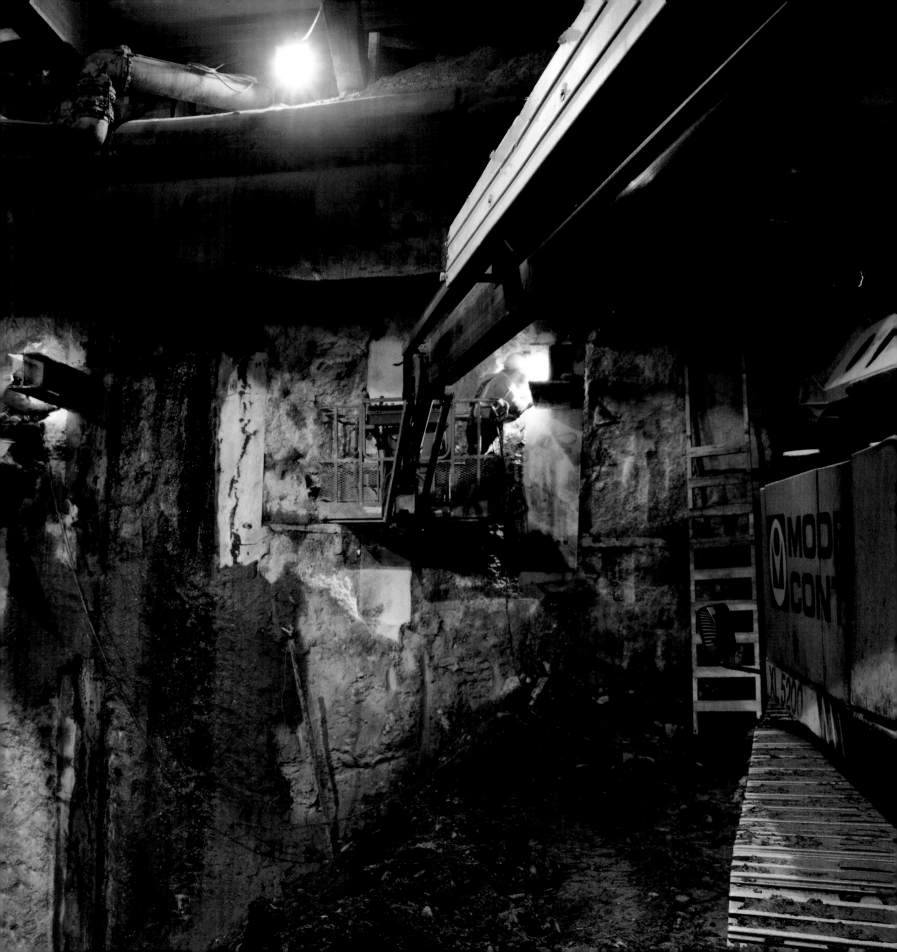

The slurry wall to the left is holding back
Boston Harbor, on the edge of the Atlantic
Ocean, near Rowes Wharf. A special low-
clearance Caterpillar 953 waits for the call
to push earth to an opening in the tunnel's
roof called a glory hole. A crane with a
clamshell bucket waits there to pull the
earth out of the tunnel and place it into the
back of a dump truck. Modern Continental's
John Pastore says it differently: "First a
Grady mucks out an area; then a dozer
bucket pushes and piles it under the hole,
where it gets clammed by a six-yarder
and hauled off in a trailer dump."
7:06 p.m., February 8, 2000.

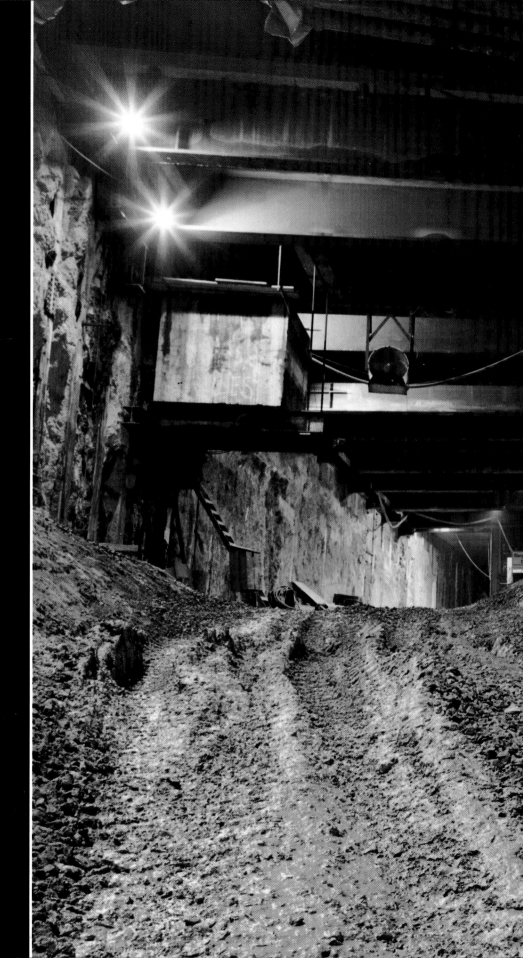

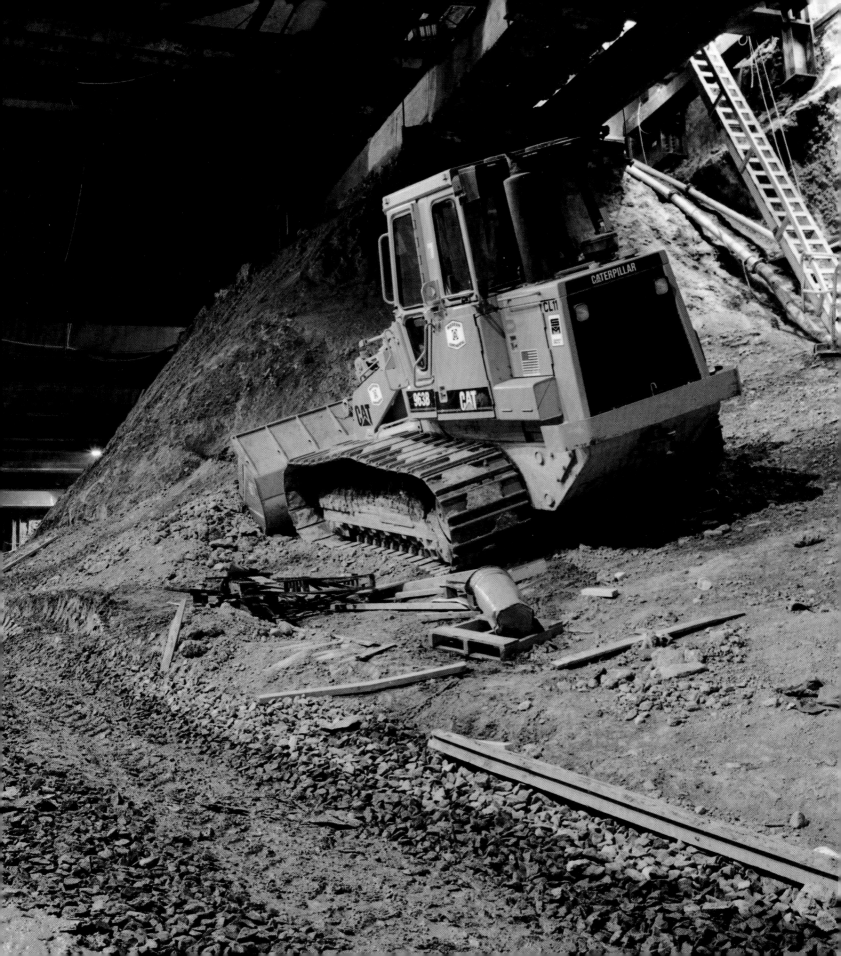

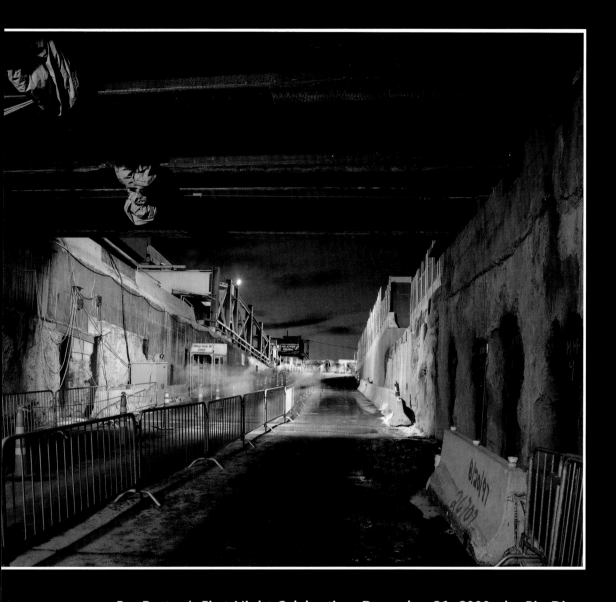

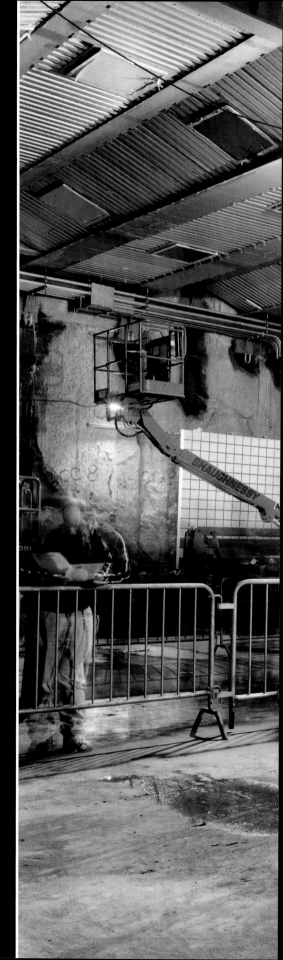

For Boston's First Night Celebration, December 31, 2000, the Big Dig opened to the public at large for the first time. "In the course of six hours, 30,000 people filed into the superhighway tunnel to kick its tires. They were awestruck! For all of us working on the project it was our proudest moment," says Senator John Quinlan. Above: The future northbound off-ramp to the Callahan Tunnel was the entrance and exit for the First Night event. Right: Opening the tunnels to the public was the idea of field engineer John Rich (back to camera). He explains to First Nighters how a retrofitted Gradall picks up large tiled wall panels that are then fastened to slurry walls.

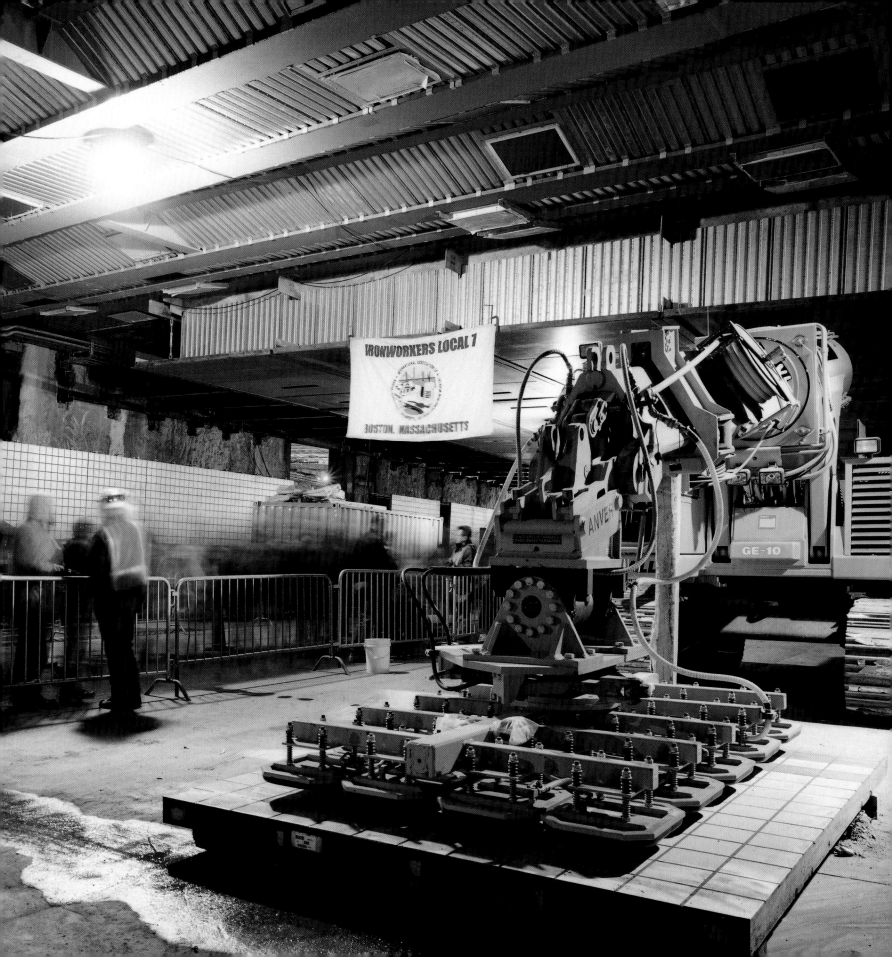

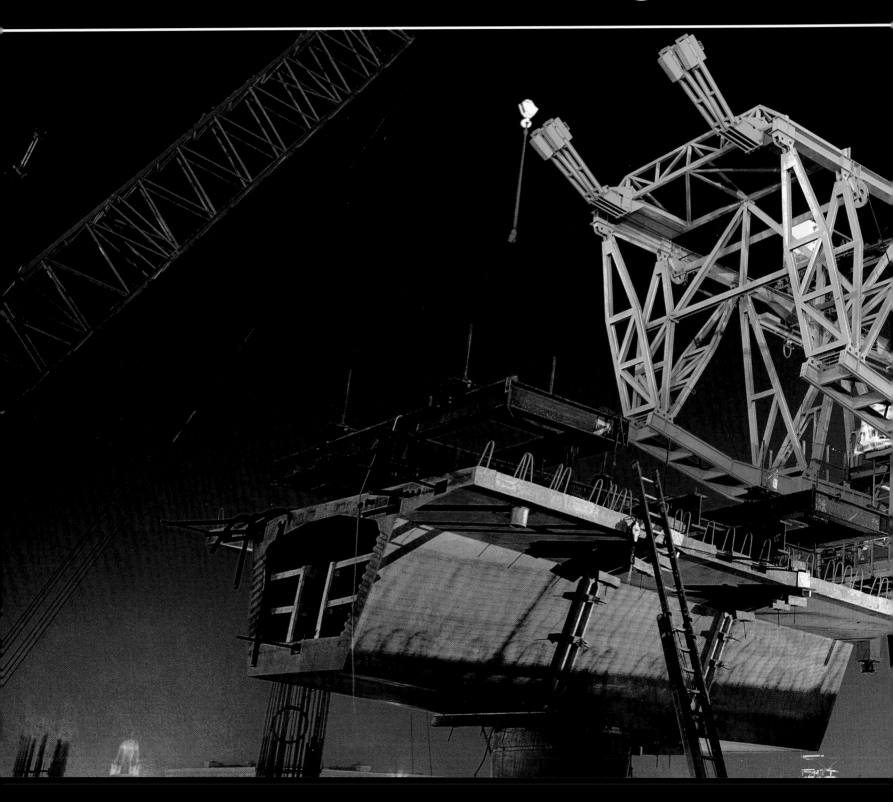

The South Rises Again

THE SOUTH BAY INTERCHANGE, where two busy interstates come together, is an incredibly complex network of ramps, tunnels, and roadways. When reconstruction is complete, I-93 will rise up and over I-90, and the interchange will permit twenty-eight separate routes to connect to local streets and interstates. While construction goes on, cars, trucks, and passenger trains roll continuously through the interchange.

1:30 a.m., August 16, 2000. Rebuilding the Southeast Expressway with a mammoth 475-foot crane. The Big Dig's biggest machine was custom-built for this project by the Italian firm Deal. Using its pod "feet," the yellow giant prepares to launch itself to the next bridge pier to the left.

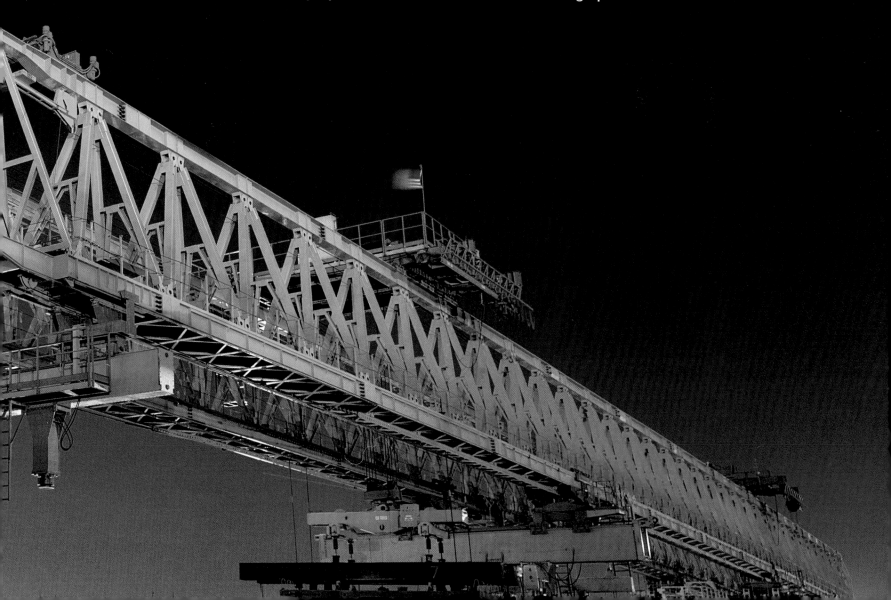

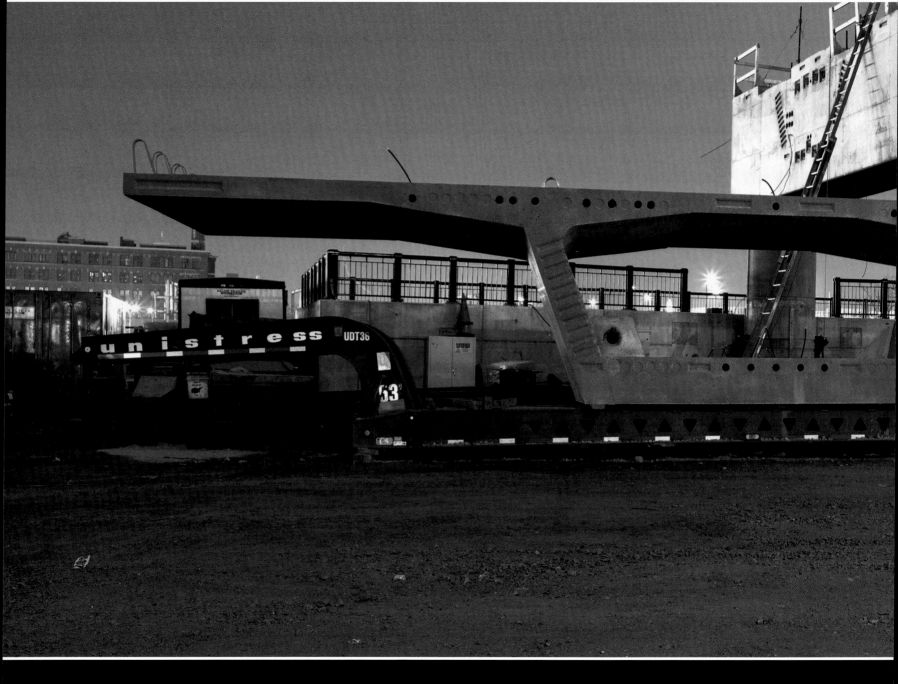

10:52 p.m., July 18, 1999. The gantry crane will lift this four-lane, 40-ton section of bridgework from the back of a flatbed trailer. Thousands of prefabricated viaduct sections like this one are

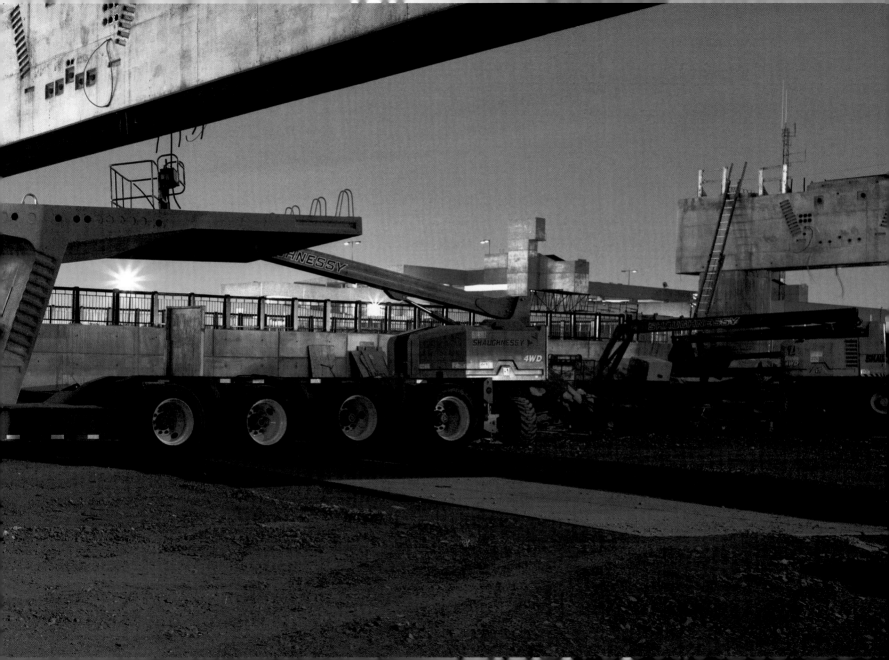

11:30 p.m., April 11, 1999.
Like a species discarded by evolution,
the gantry crane may never be used
again when its work on the Big Dig
is completed. Here, it continues to
build the I-93 viaduct as it approaches
the South Bay Interchange.

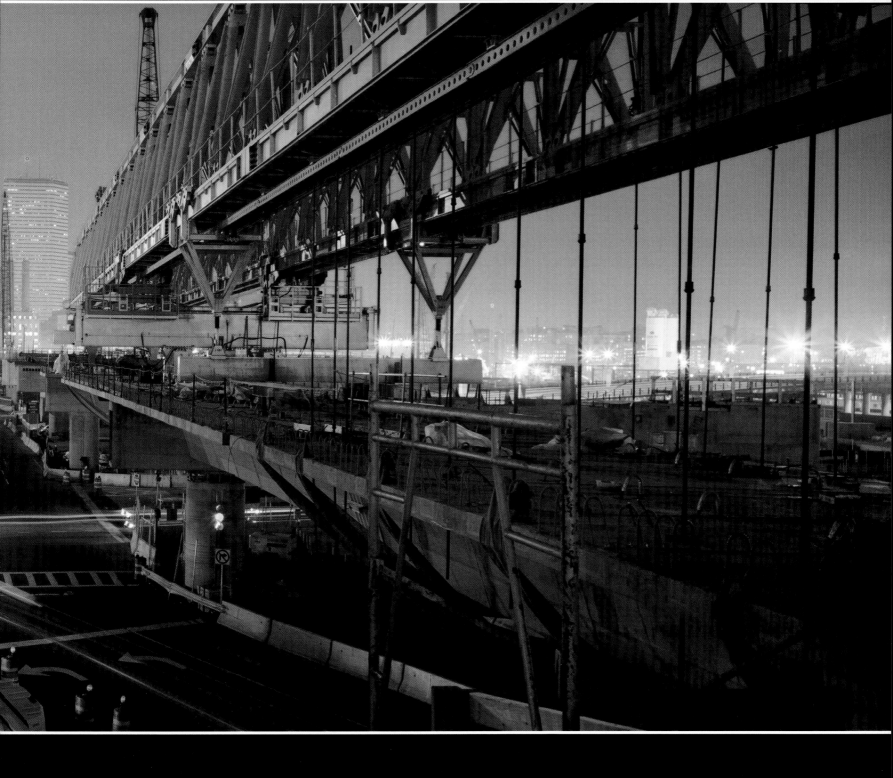

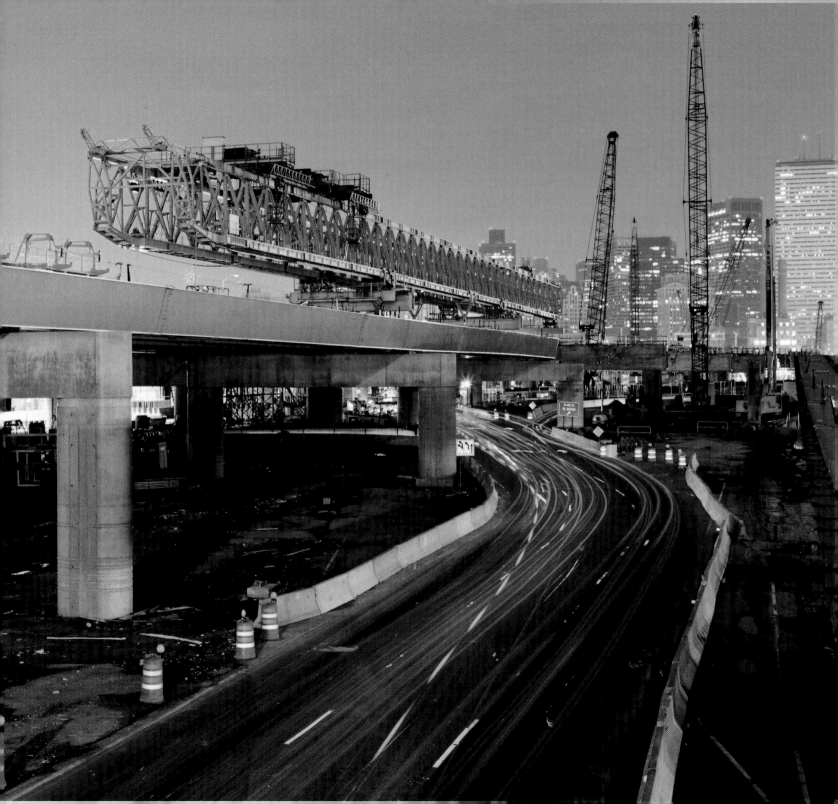

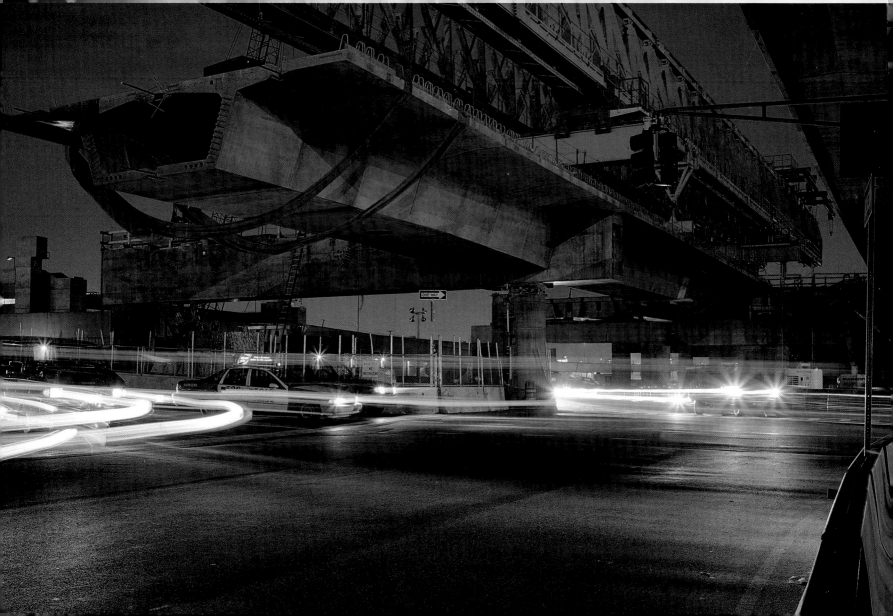

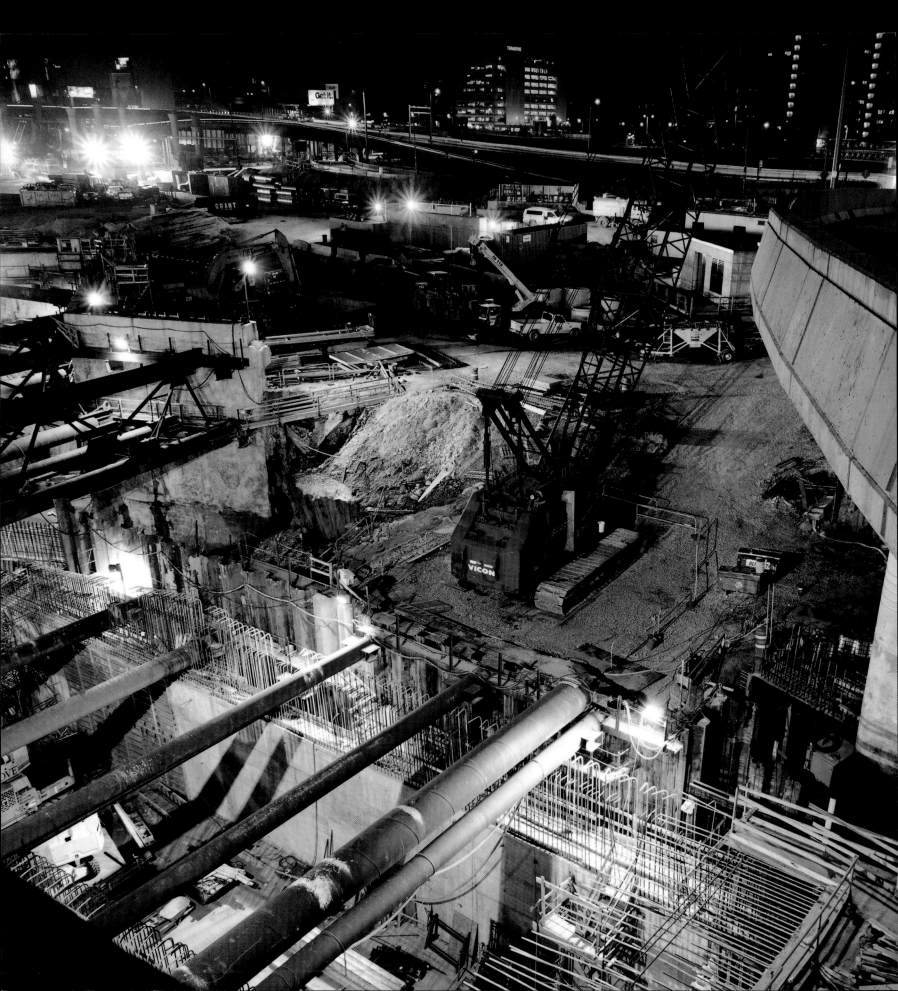

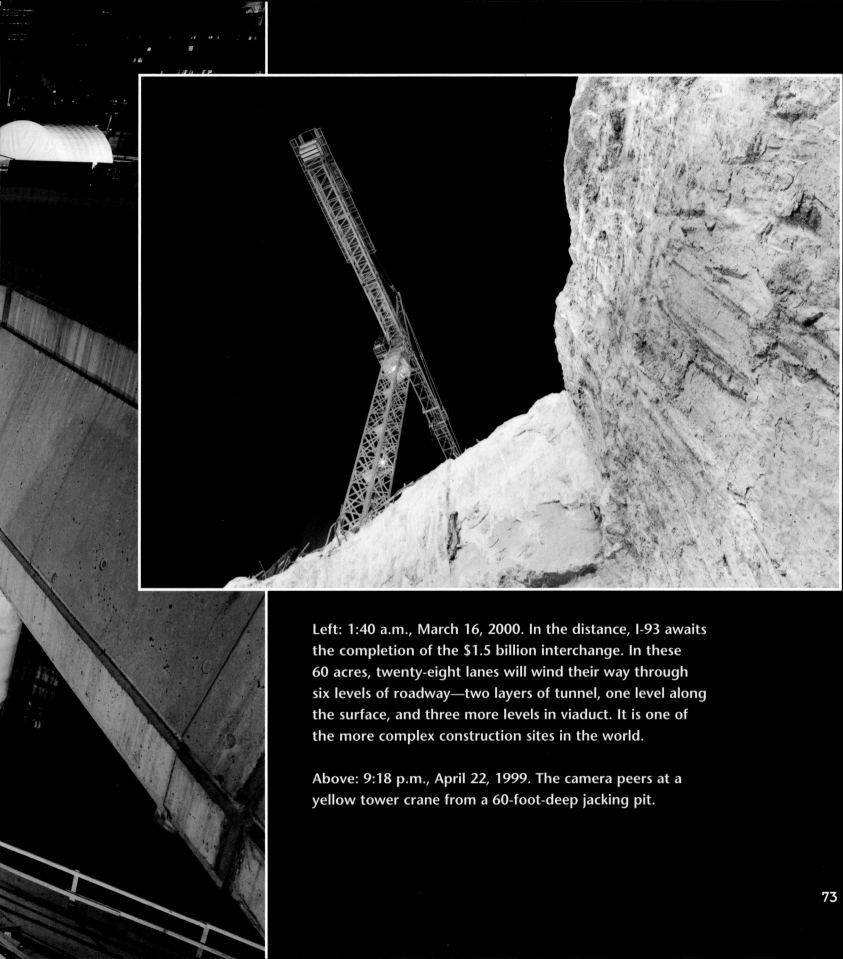

Left: 1:40 a.m., March 16, 2000. In the distance, I-93 awaits the completion of the $1.5 billion interchange. In these 60 acres, twenty-eight lanes will wind their way through six levels of roadway—two layers of tunnel, one level along the surface, and three more levels in viaduct. It is one of the more complex construction sites in the world.

Above: 9:18 p.m., April 22, 1999. The camera peers at a yellow tower crane from a 60-foot-deep jacking pit.

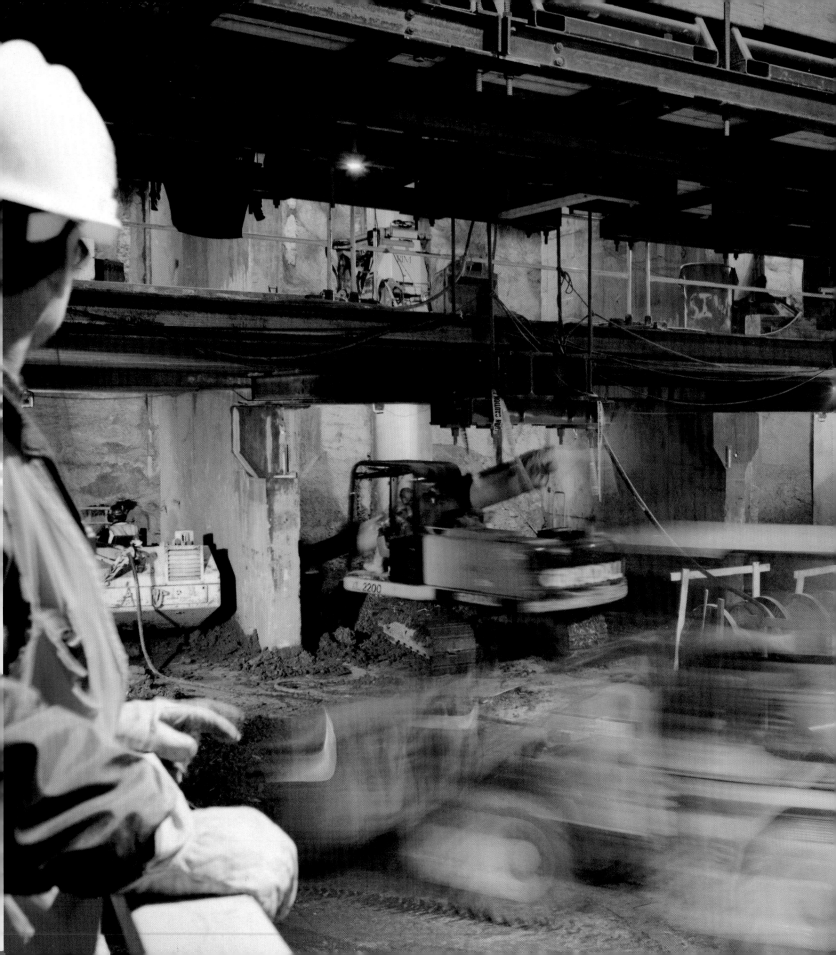

6:33 p.m., October 21, 1999.
Inside one of the South Bay's three
jacking pits, David Walbourne of
Slattery Skanska Construction
waits for the big push. Over a
period of two months, this 17,000-
ton section of highway tunnel was
pushed, or jacked, over 180 feet,
three feet at a time, as part of the
largest jack-tunneling operation
in the world. By January 2001
three separate tunnels with a
total weight of 75,000 tons
were successfully pushed to their
destinations—in some cases just
five feet below moving Amtrak
and MBTA trains.

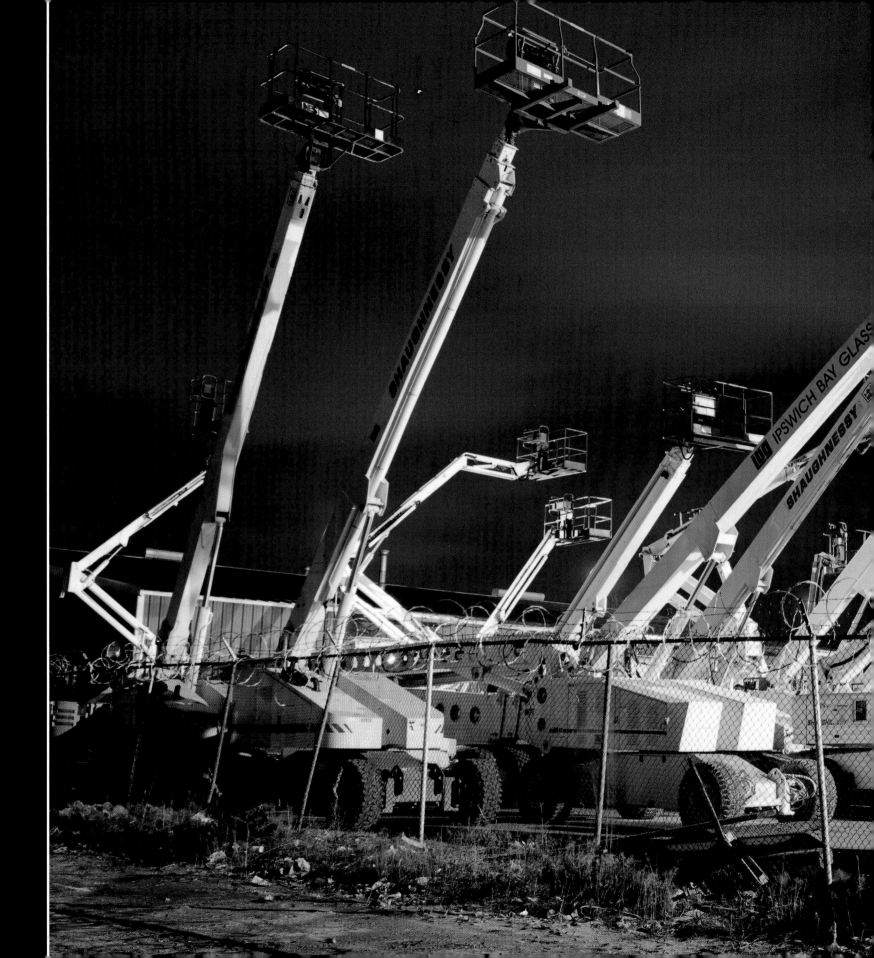

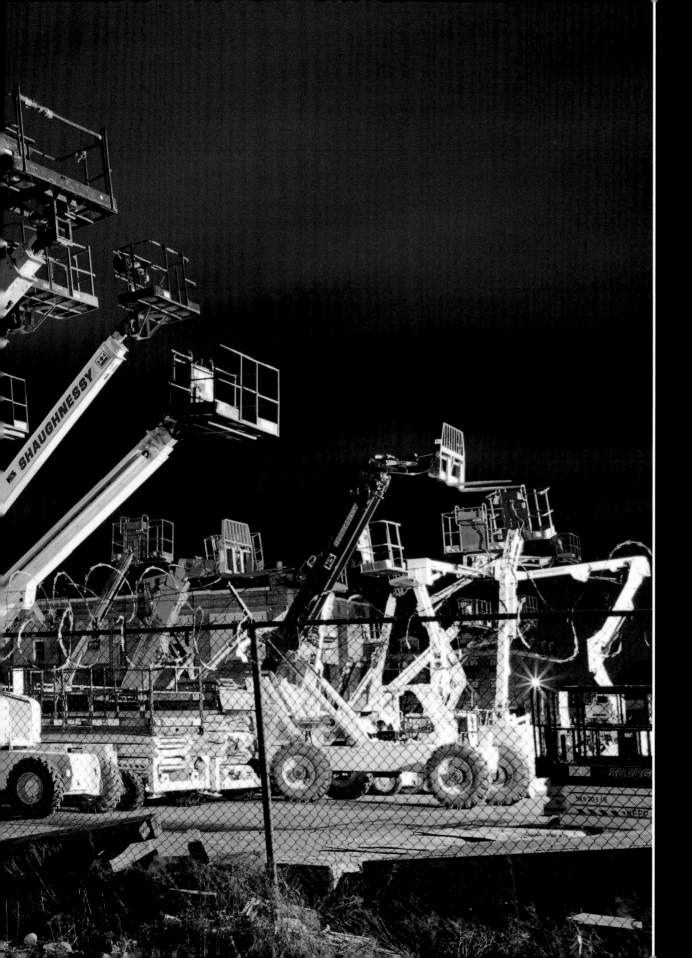

11:11 p.m.,
March 22, 2000.
Caged in a field,
the cranes rise into
the night sky at
Shaughnessy's crane
farm in South Boston.
Rented to Big Dig
contractors, the cranes
assist in almost every
type of job imaginable:
underpinning the
old elevated highway,
building bridges,
replacing floodlights,
and waterproofing
tunnel sections.
Local 103 electrician
Hannah Blum explains,
"In the tunnels, it's
hard to do anything
without a man lift, and
in the mornings we
have our own traffic
jam, with lifts going in
every direction."

The Fort Point Channel and Beyond

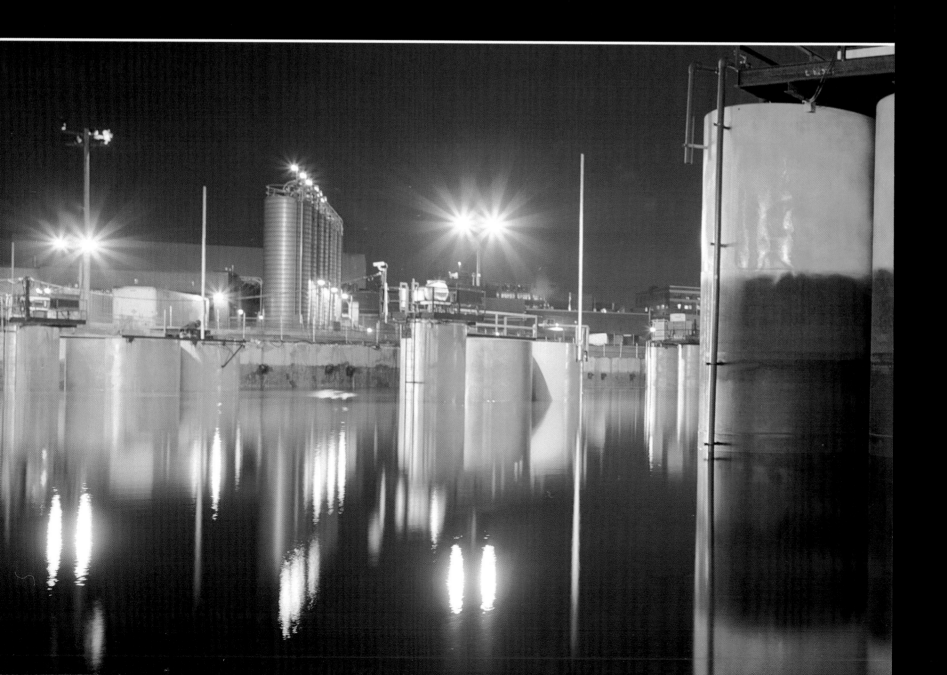

THE FORT POINT CHANNEL divides downtown from South Boston. By day or night, crossing the channel's shallow, muddy water proved to be one of the Big Dig's greatest challenges. Stabilizing the channel's notoriously weak soil was just one of many complex problems to be solved before construction of the tunnel could begin.

Yellow stabilization cylinders rest on the tops of gigantic tunnel sections. Strictly utilitarian by day, they become strangely beautiful in the night light. 3:00 a.m., December 21, 1999.

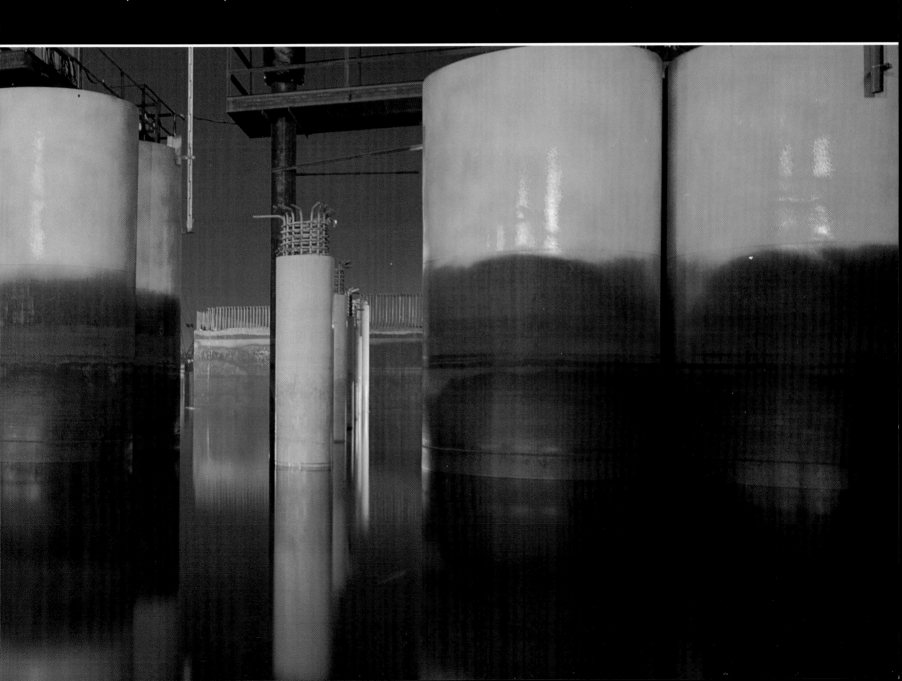

The gigantic 15-foot-wide triple augers, or "cake mixers," on this Manitowoc M250 were used to inject Portland grout 120 feet into the earth. Utilizing a technique developed by the Japanese, the Big Dig performed one of the world's most extensive deep-soil mixing operations. This procedure stabilized the weak soil in the Fort Point Channel, preparing it for I-90's eleven lanes of highway tunnel through the channel. 11:37 p.m., July 8, 1999.

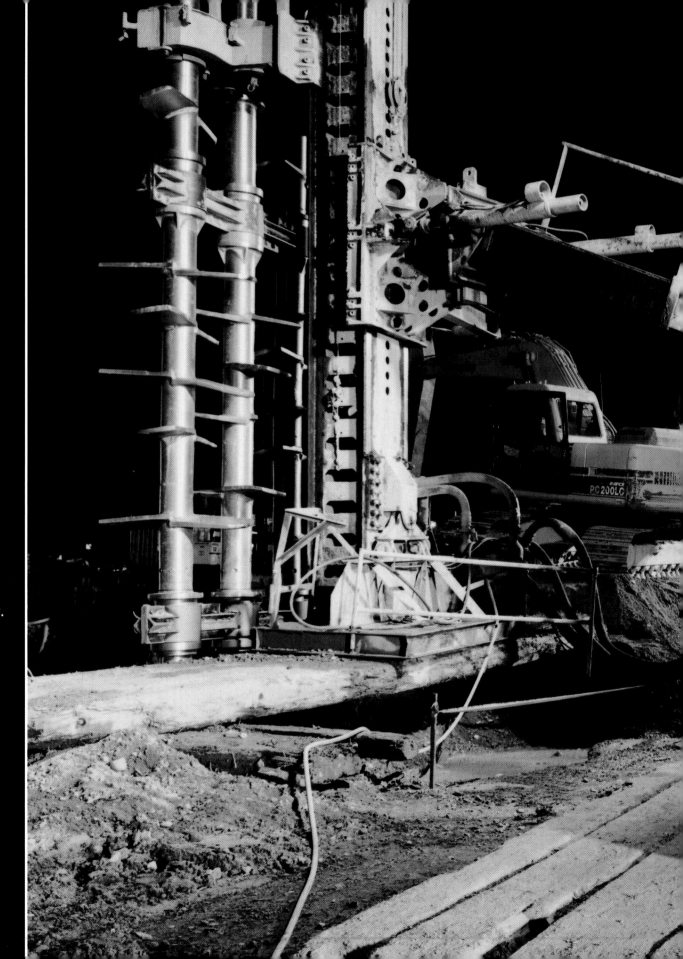

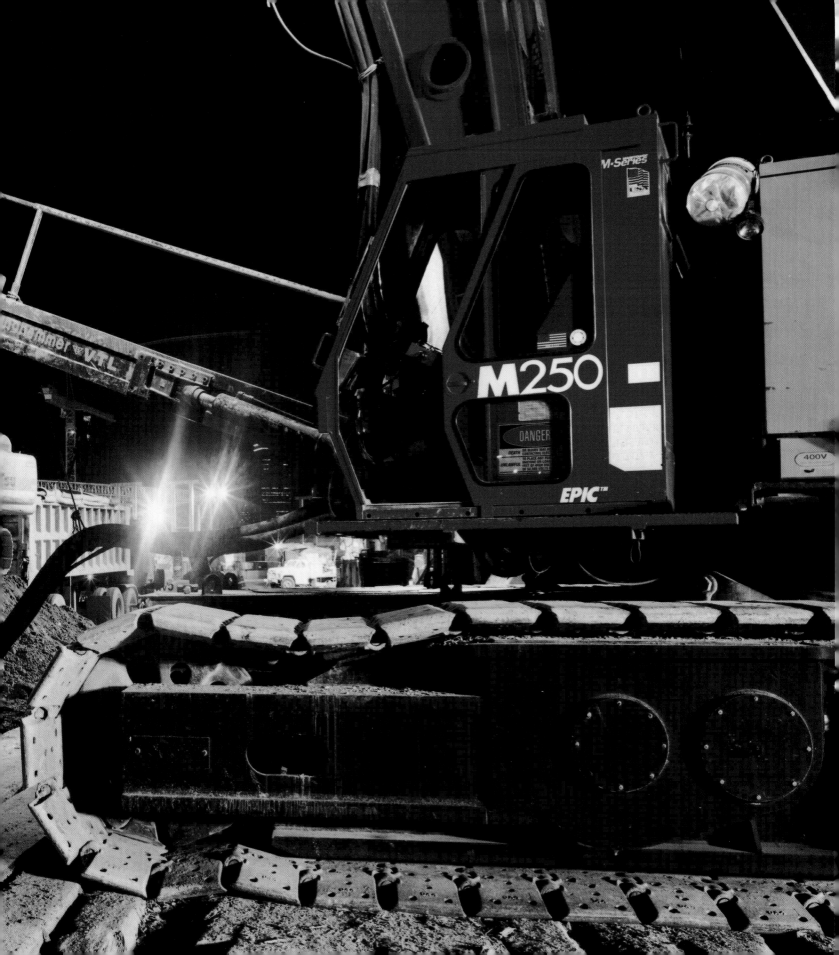

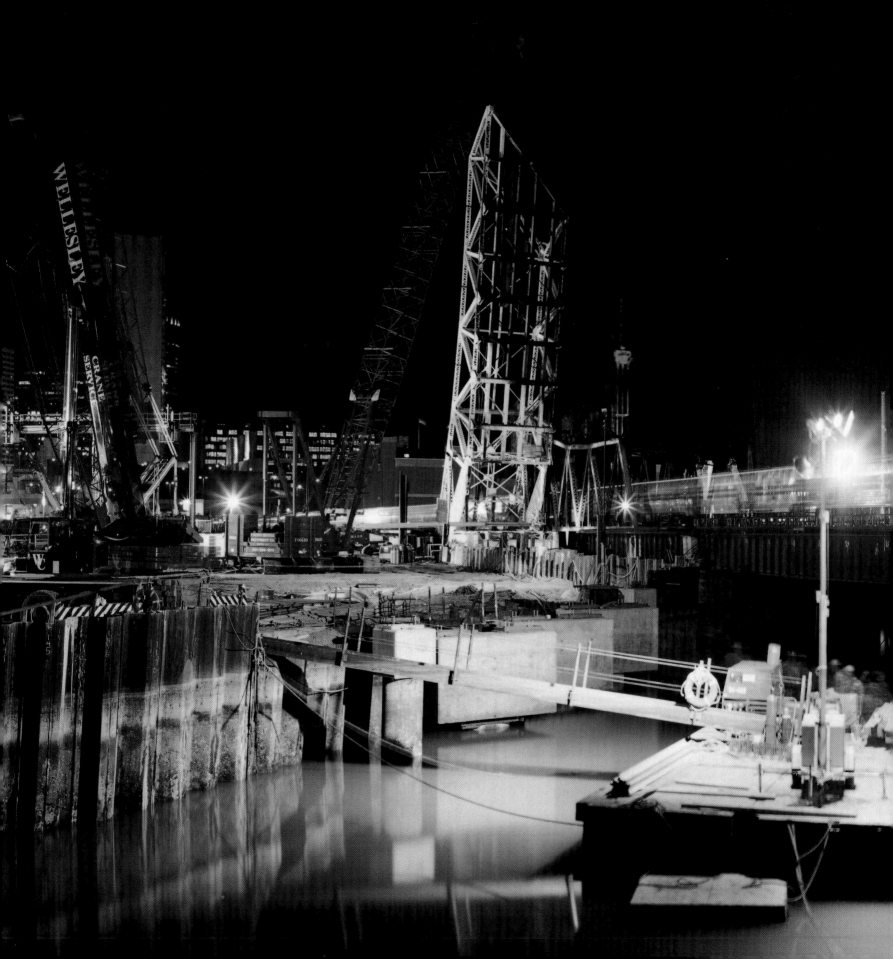

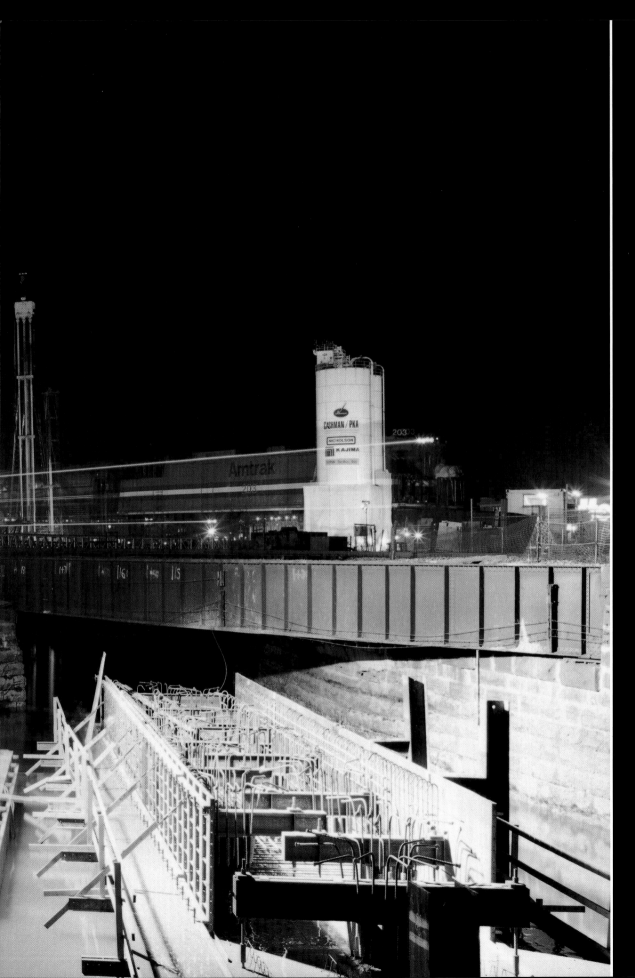

9:50 p.m., September 10, 1998. For the first time since the 1960s, the New York, New Haven and Hartford Railroad Bridge is lifted over the Fort Point Channel. Sadly, it was one of the last times the bridge would rise. Built in 1898 to service South Station, the Old Colony Railroad Bridge, as it was also known, had been an inspiration for local artists for over a hundred years. But time and technology passed it by, and it was demolished to make room for the Big Dig.

83

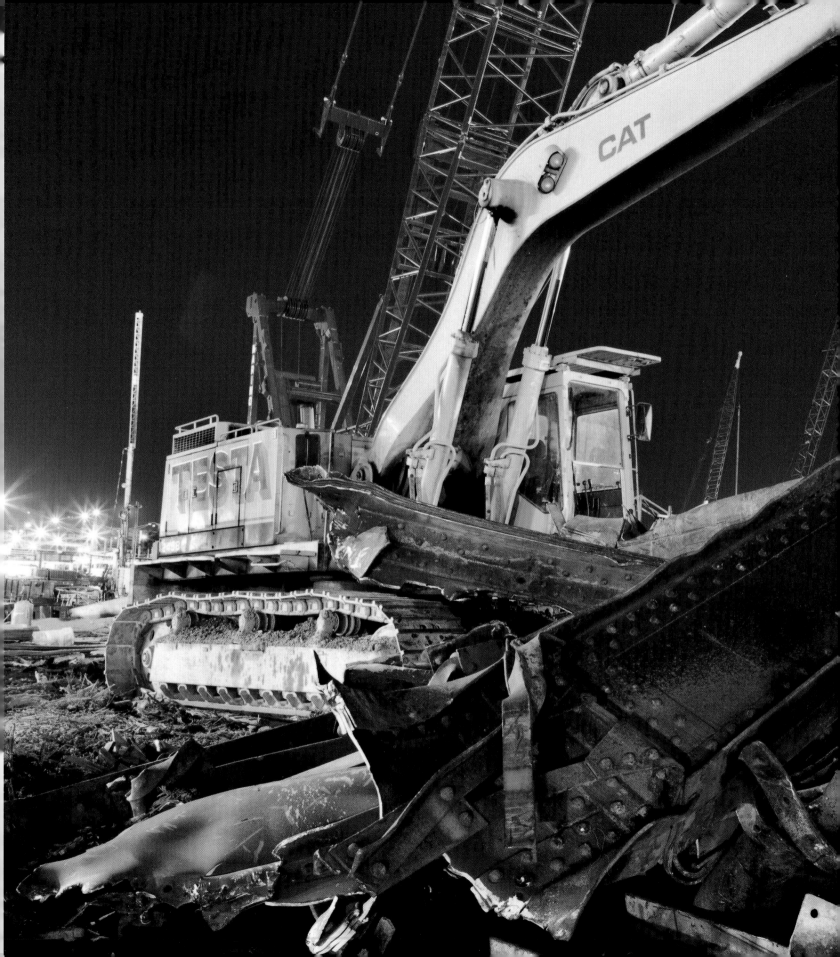

11:02 p.m., July 8, 1999. After trying unsuccessfully for years to give the bridge away, a demolition crew destroyed it, using the shears of this Caterpillar 245. So strong are the sentiments for the old bridge that pieces of it have been saved and a sculpture in its honor is planned near the site where it operated for over one hundred years.

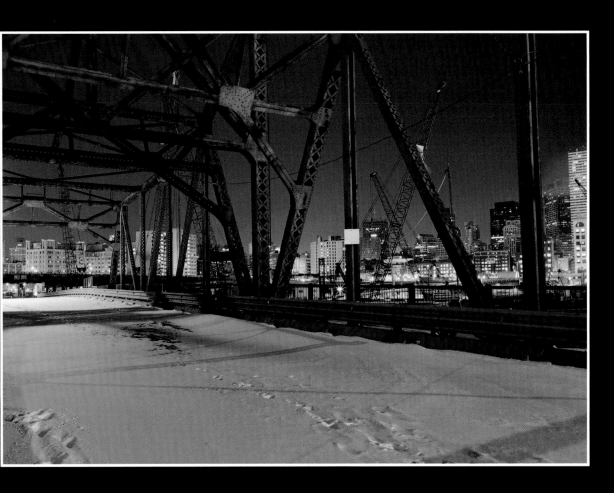

The Broadway Bridge, a stone's throw from the Old Colony Railroad
Bridge, met the same fate. Above: 1:16 a.m., February 24, 1999.
The Broadway Bridge is closed to traffic forever. Horses and carriages,
streetcars, motor vehicles, and pedestrians used the bridge for over
one hundred and thirty years.

Right: 2:20 a.m., March 4, 1999. Built and rebuilt over the years, the
contemporary bridge contained only parts of the original 1869 bridge.
The center masonry substructure dates back to 1875. Commercial traffic in
the channel was extremely hectic a century ago. In 1906 alone, the gears
on top of the substructure allowed the bridge to open over 2300 times.

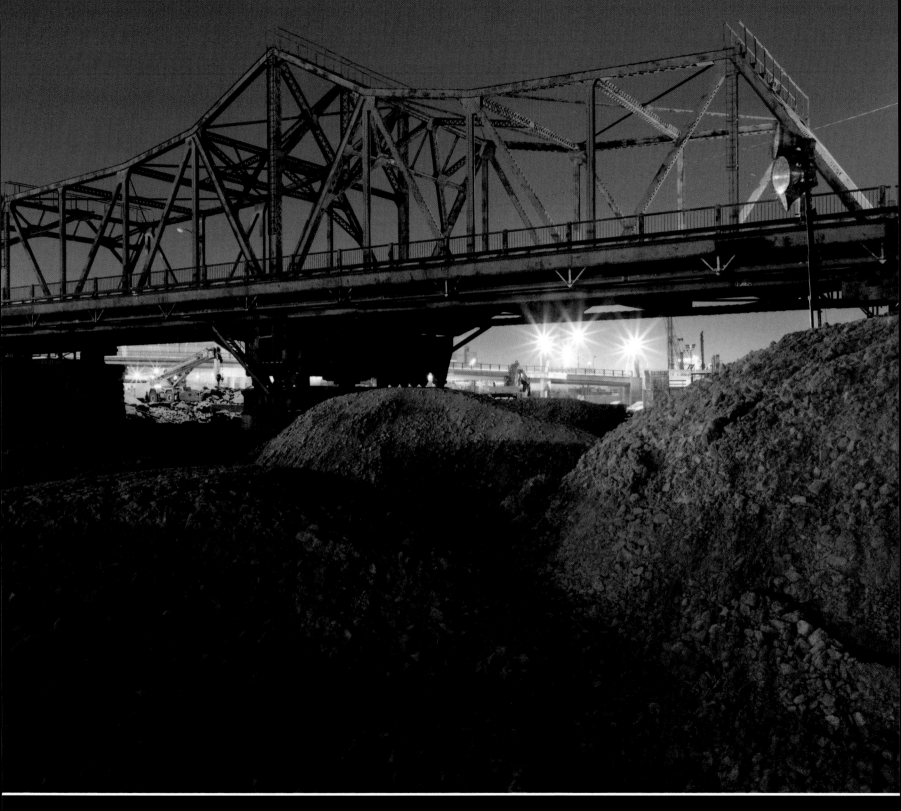

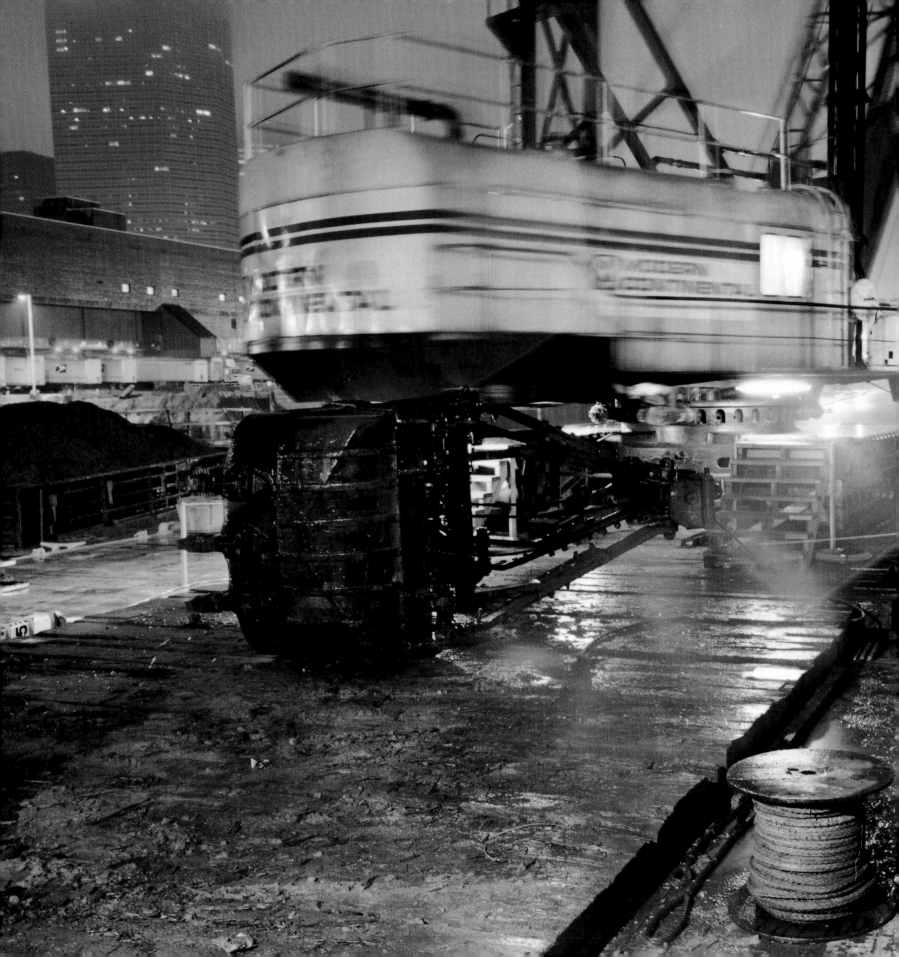

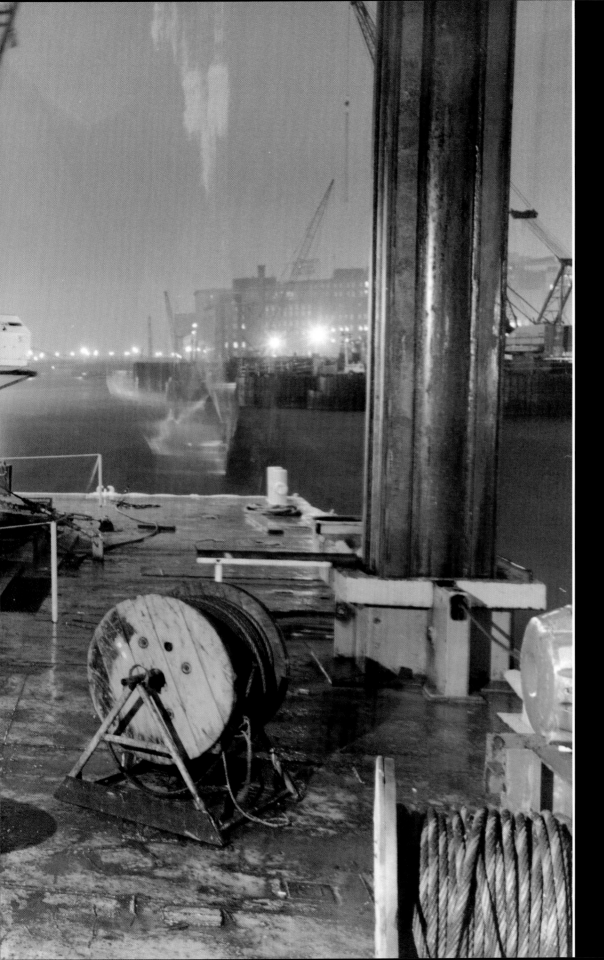

1:18 a.m., March 22, 2001. With gale winds blowing from the northeast, the operator of this 2400 Lima crane carefully dredges around the Red Line subway. He skillfully follows the beam of a red laser that marks the exact location for the tunnel under the channel. Immersed tube tunnel sections, the largest in the world, wait off to the right in the casting basin. The sections will soon come to rest just four feet from the subway tunnel's roof.

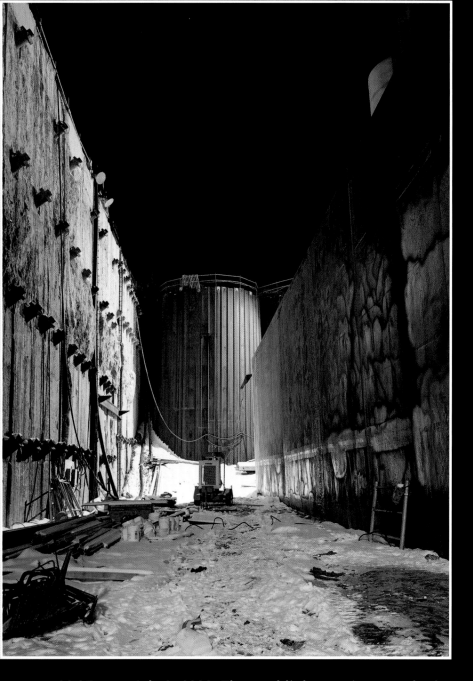

11:37 p.m., July 8, 1999. The world's largest immersed tube
tunnel sections were cast in a gargantuan casting basin
three times wider than the locks of the Panama Canal.
Right: Inside the casting basin, a waterproofed tunnel section
waits for "float-out." Above: The floor of the casting basin.
12:40 a.m. and 12:03 a.m., February 20, 2001.

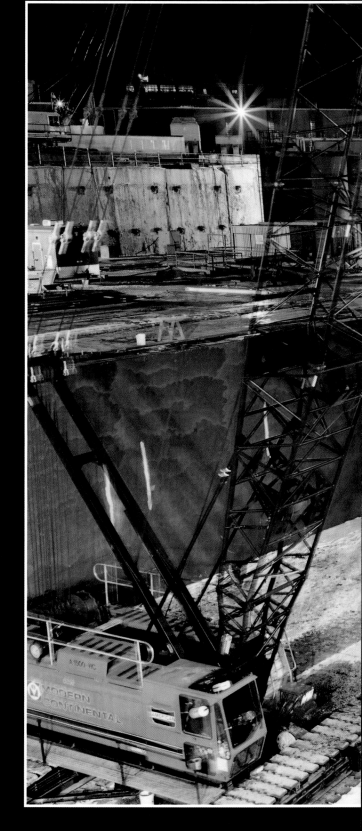

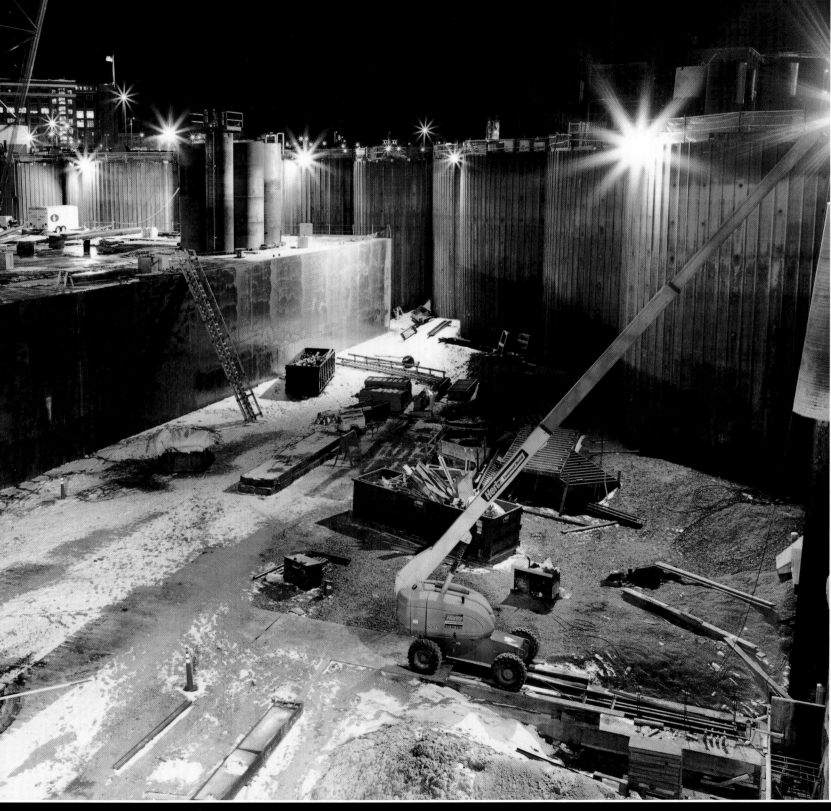

1:12 a.m., February 20, 2001. Inside the casting basin, under fire-retardant blankets, ironworkers weld stiffeners to the steel bulkheads of a tunnel section. Once the casting basin is flooded, the 52,000-ton section will be floated out. Over 2000 large anchors hold back the walls of the basin.

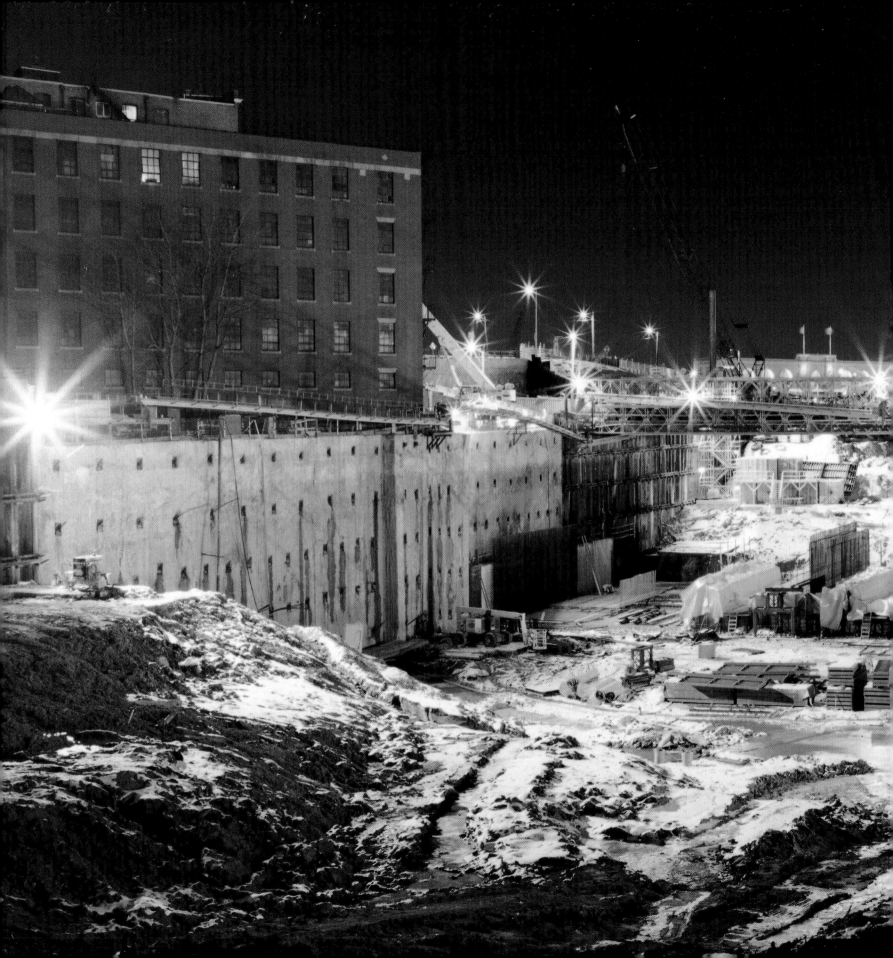

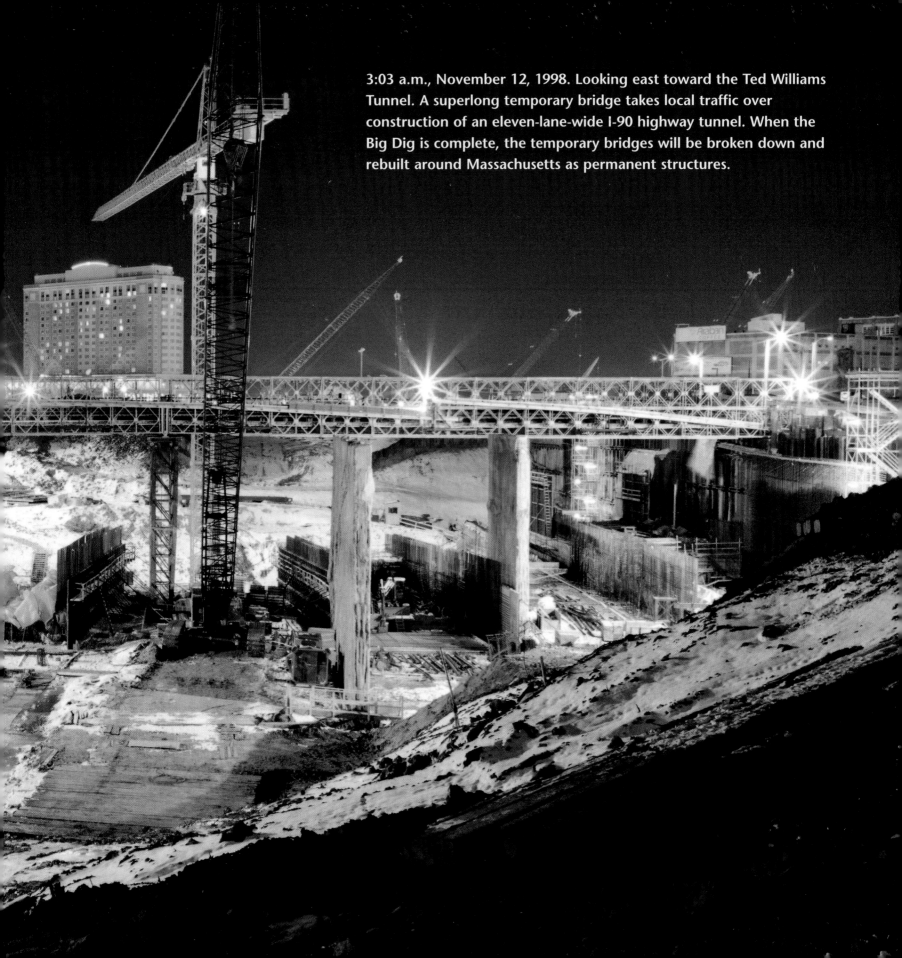

3:03 a.m., November 12, 1998. Looking east toward the Ted Williams Tunnel. A superlong temporary bridge takes local traffic over construction of an eleven-lane-wide I-90 highway tunnel. When the Big Dig is complete, the temporary bridges will be broken down and rebuilt around Massachusetts as permanent structures.

The Seaport District, South Boston. An ironworker is "hooked in" to a wall of reinforcement steel. At this location, the tunnel serves as the foundation for an enormous ventilation building that services the tunnels. The reinforcing steel, called rebar, gives the wall strength. The heavy boom of a large crane can be seen to the left. 11:22 p.m., January 26, 2000.

11:38 p.m., January 26, 2000. Seaport District, South Boston. An emerald forest of green epoxy-coated rebar. The epoxy protects the steel bars from Boston's salty air and water. In eight hours, the day crew's army of ironworkers will arrive back on the jobsite to tie the rebar into the tight patterns visible at the bottom of the picture. This procedure gives the tunnel the strength it needs to resist wind loads and earthquake forces, in addition to the weight of office towers and other structures that will be built above it, according to Alleyn Alie, the resident engineer at this location.

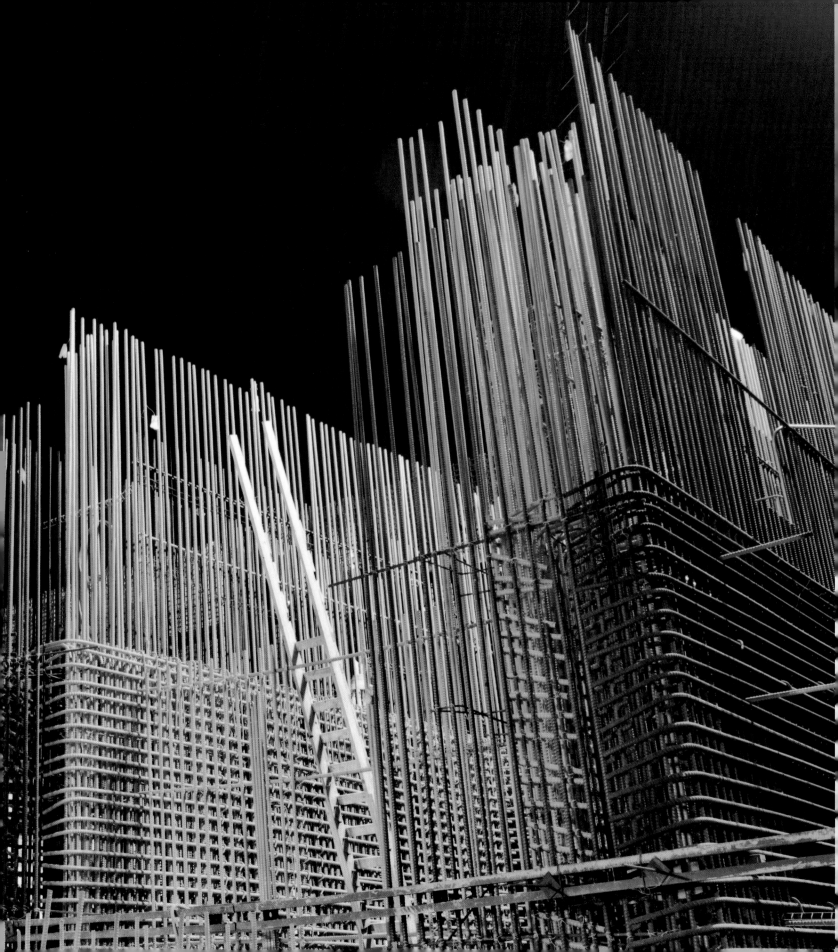

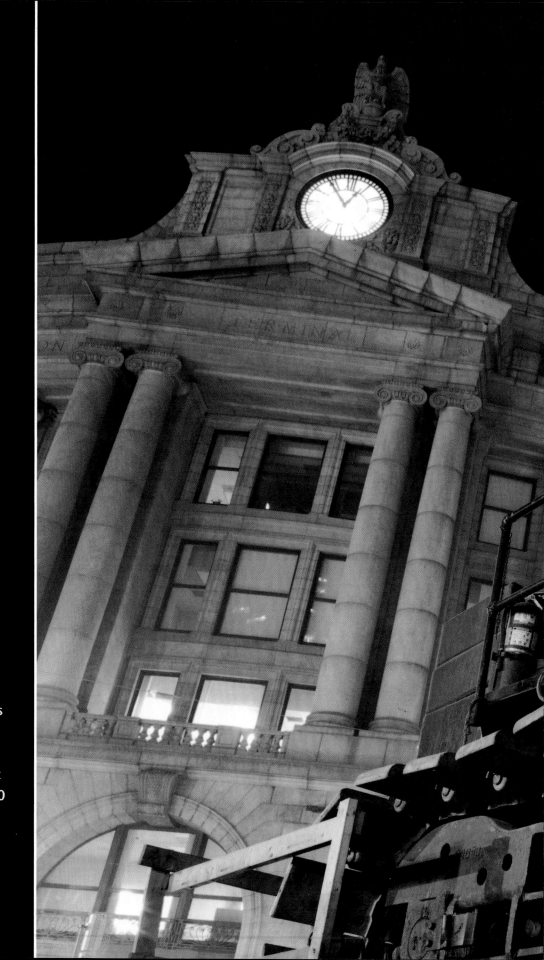

CHAPTER SIX

The Deepest Dig

THE DEEPEST PART of the Big Dig is located near South Station Terminal Building, where nocturnal work crews— The Night Cats—are building four northbound lanes of I-93, 120 feet belowground.

12:52 a.m., January 10, 2000. South Station Terminal Building. Says Perini Corporation's night foreman Frank Nee, "The old 9270... the thing was built in the '70s, and it's the most reliable crane we've got on the job. It has less downtime than the new $1,400,000 rigs at the other end of Atlantic Avenue."

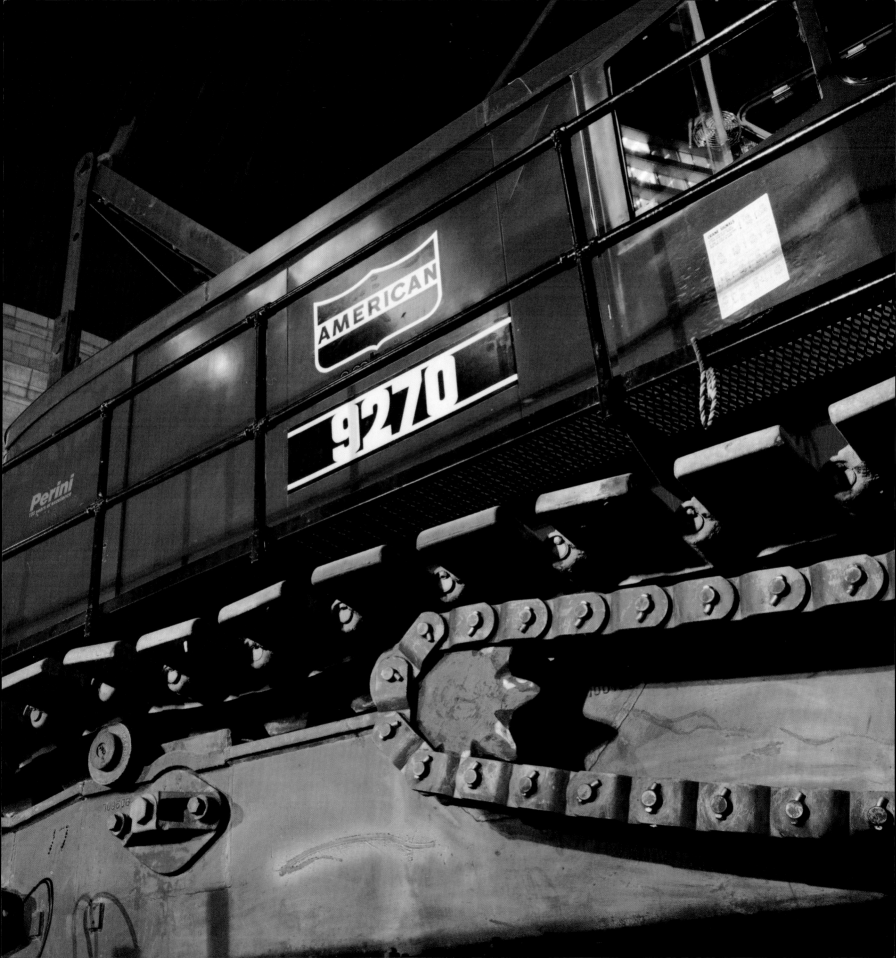

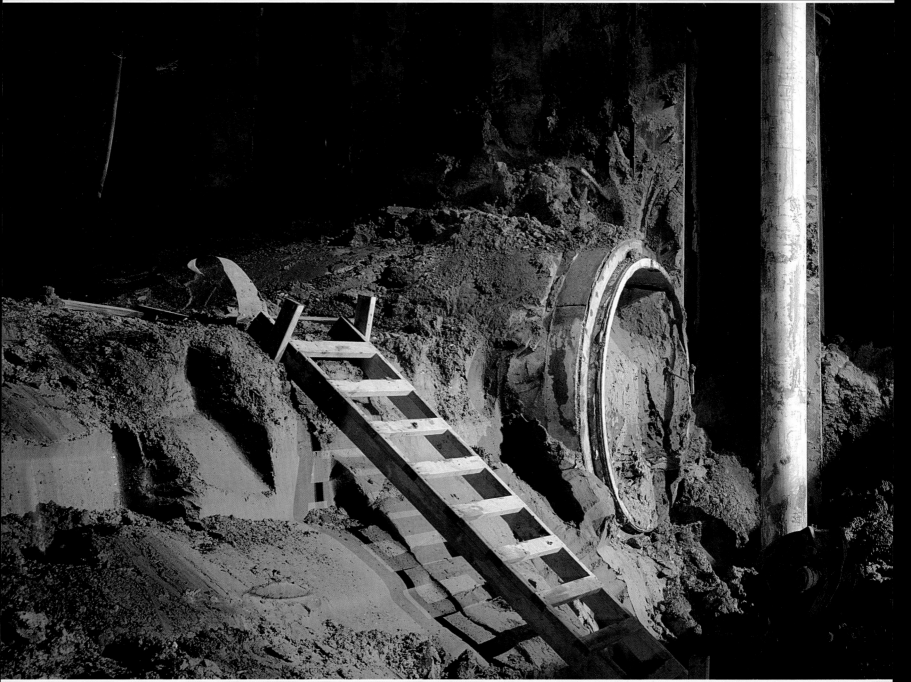

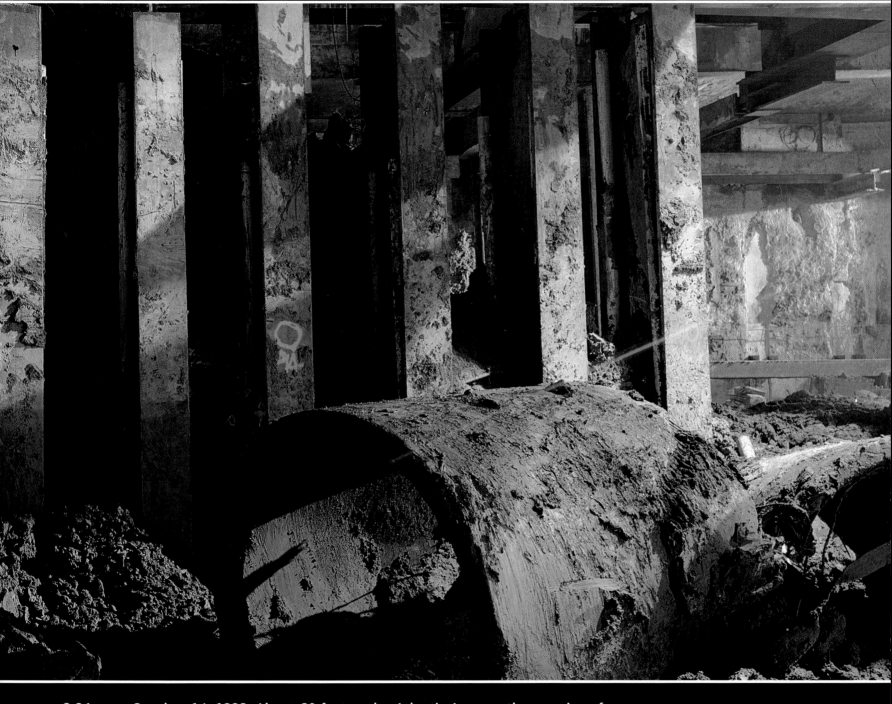

2:26 a.m., October 14, 1998. About 20 feet under Atlantic Avenue, the remains of the New East Side Interceptor, a drainage line installed under Atlantic Avenue in the late 1970s. The original interceptor was built in the 1920s. Between 1991 and 1997, the Big Dig employed thirty-one utility companies to replace thousands of miles of phone, gas, thermal electric, and water lines at a cost of over $600,000,000.

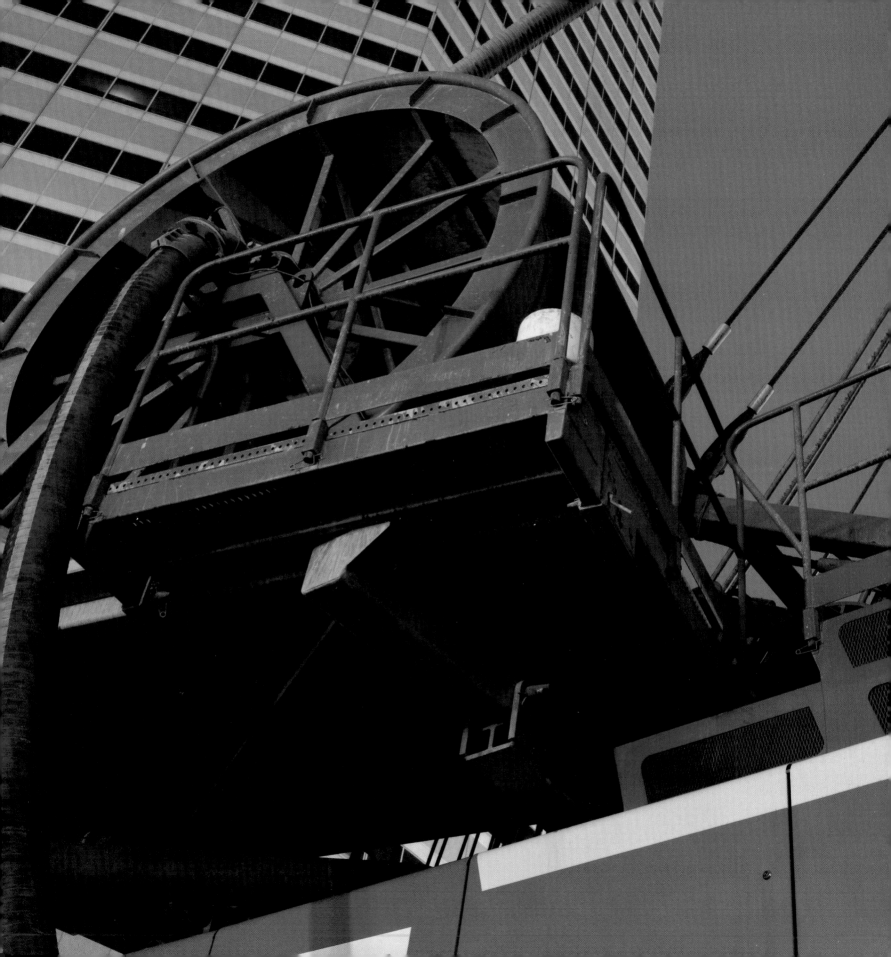

10:19 p.m., September 23, 1998.
The multimillion-dollar orange Hydro-Fraze,
custom designed for building slurry walls,
was a fixture at South Station for four years.
"Solentache, a French company, outfitted a
large German Liebherr tractor crane with
computers, pipes, hydraulics, and twin
rotating cutter heads to dig the tunnel wall,
130 feet deep," explains field engineer Ken
Hatfield. "Four French technicians lived here
for years to support the rig's mechanics.
Local 4 operators drove the machine for us,
and the French guys kept it running."

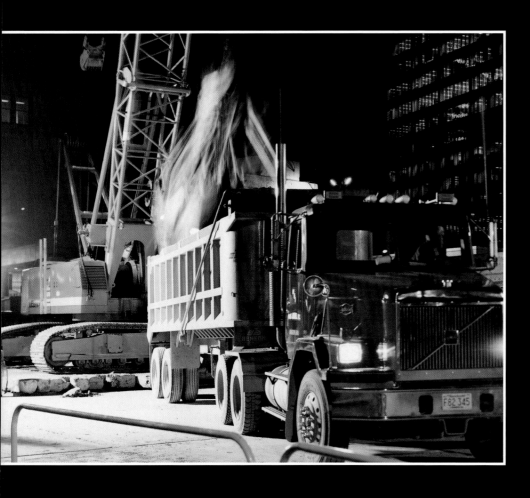

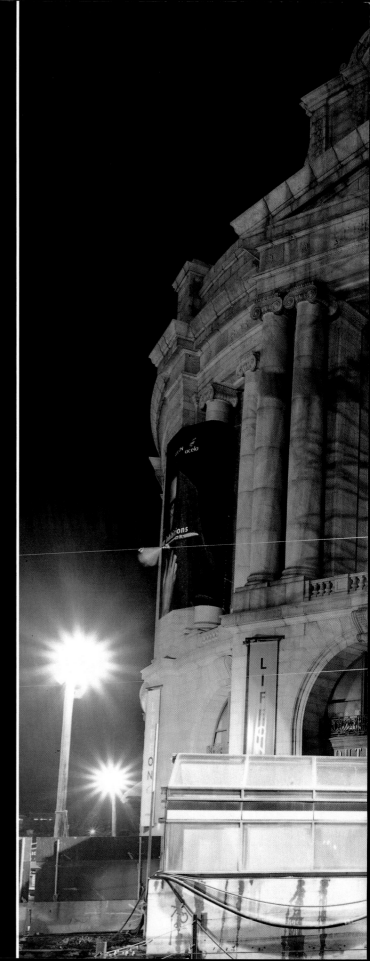

Above: 2:46 a.m., October 1, 1998. A trailer dump is loaded with a 10-ton clam bucket. Right: 2:20 a.m., February 10, 2000. South Station, opened in 1898, was the largest train terminal in the world, running seven hundred and twenty-eight daily arrivals and departures at its peak. Today, it is once again the center of transportation in Boston—the Hub of the Hub. Field engineer Dan Maurano says, "The tunnels here are like Mom's lasagna, four layers thick. The Red Line subway tunnel is 70 feet below the yellow Liebherr crane. Four lanes of I-93 will pass beneath the Red Line and the new Silver Line transit tunnel above it. A lobby for both the Silver Line and Red Line is being built beneath Atlantic Avenue and over the Silver Line tunnel."

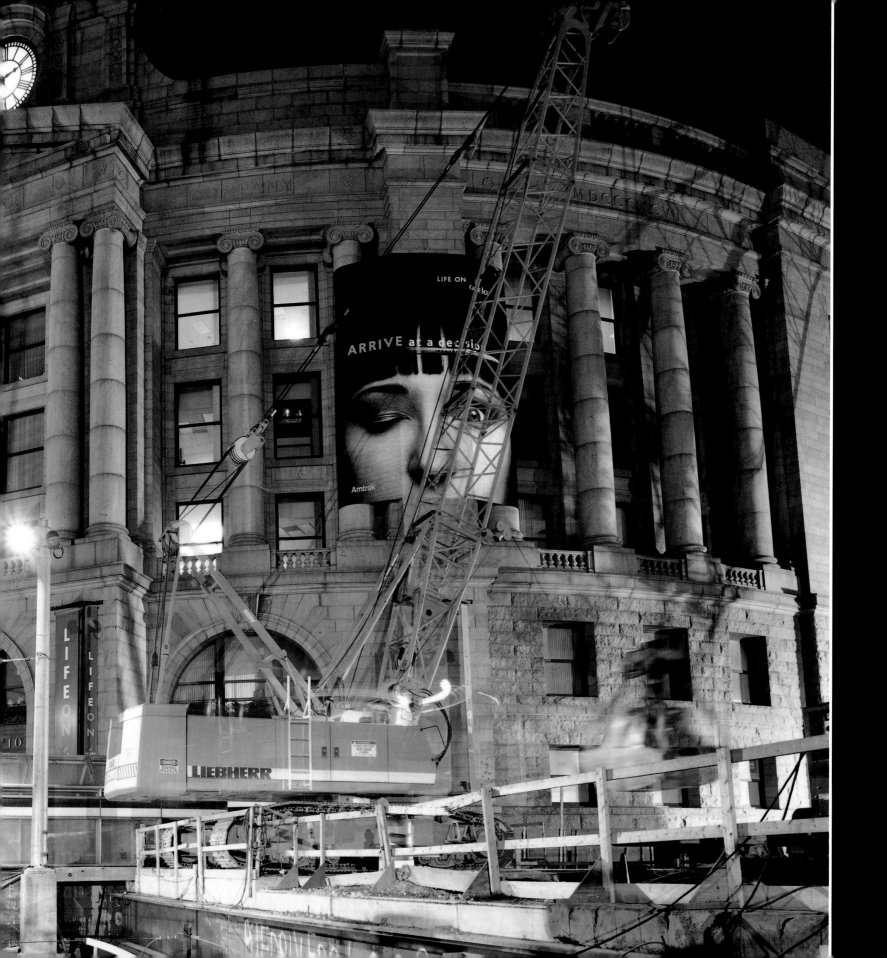

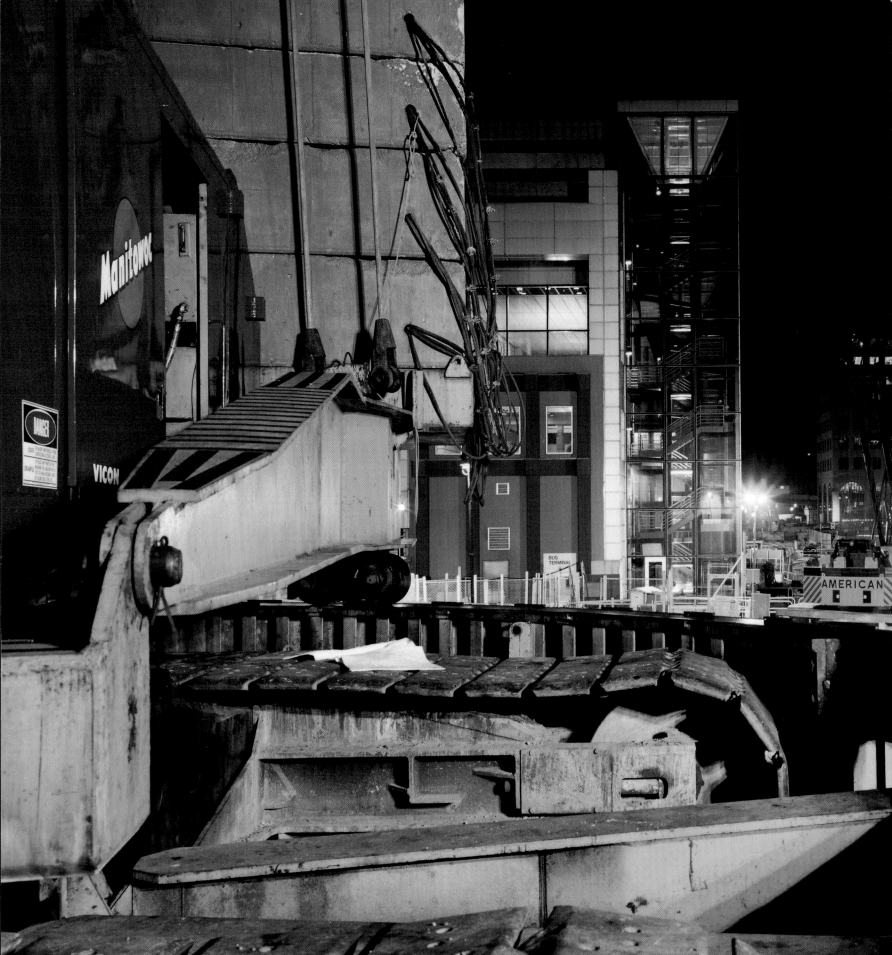

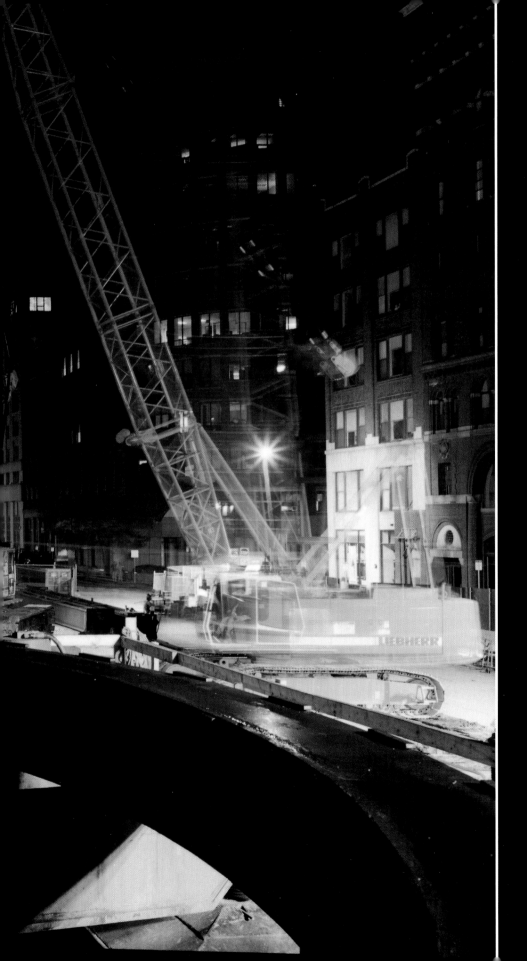

1:16 a.m., October 6, 1998.
Looking south on Atlantic Avenue between the bus terminal and the century-old buildings of Boston's Leather District. Tom McCormack describes the Manitowoc 4100 ringer crane he operates: "Usually this thing is walking like any tractor crane, but for this job we've bolted down the entire rig with a heavy yellow ring. That gives it stability and increases its lifting capacity." The crane has over 300 feet of boom and can lift 300 tons. Without moving an inch, it picked up and shuttled materials along Atlantic Avenue day and night for over three years. It even hoisted a dancer from the Boston Ballet for a promotion in the spring of 1999. "Now that I didn't expect," says McCormack.

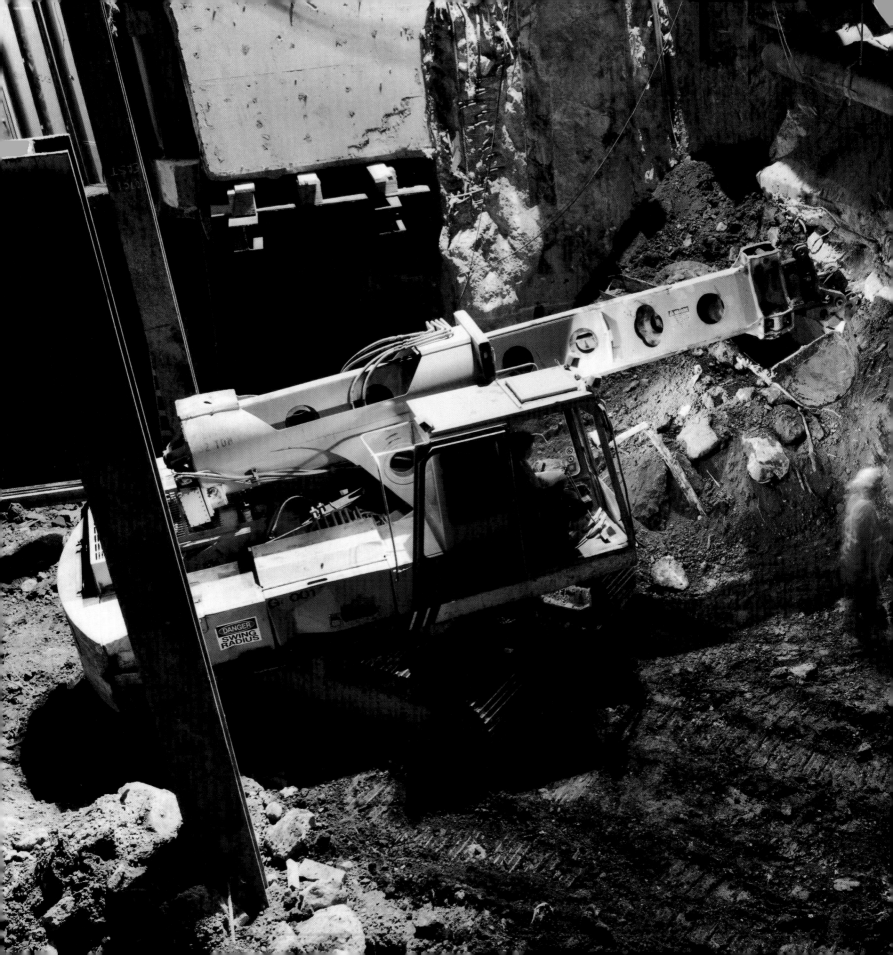

DANGER
SWING
RADIUS

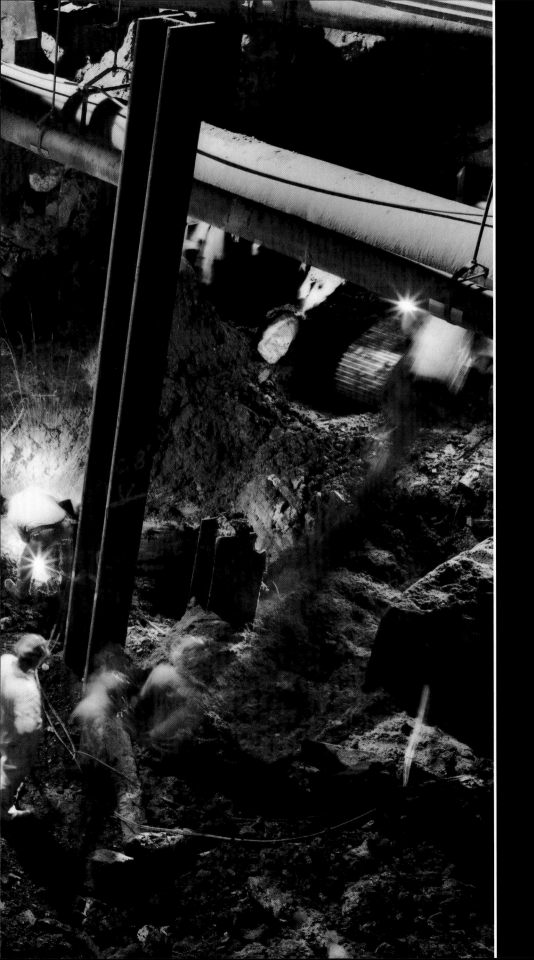

Under the intersection of Atlantic Avenue and Summer Street, on the way to the deepest point of the Big Dig. Once the site of a gas station, this area was filled with contaminated soil, and even on this hot summer night, workers wear protective suits as a Gradall 5200 navigates between three vertical pin piles. Today, the pin piles support the new Silver and Red Line subway stations. Notice the live utility lines at the upper right. 2:06 a.m., July 22, 1999.

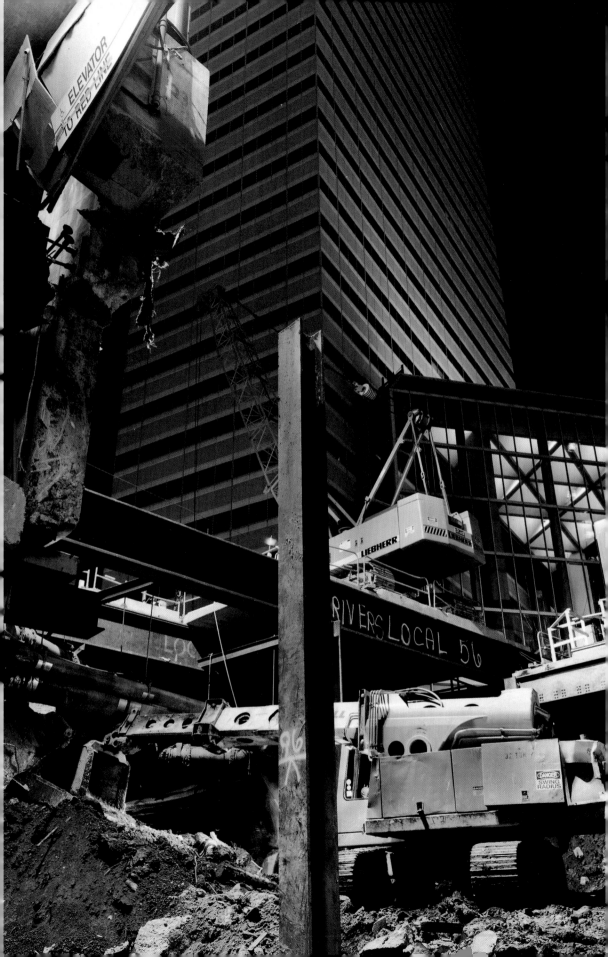

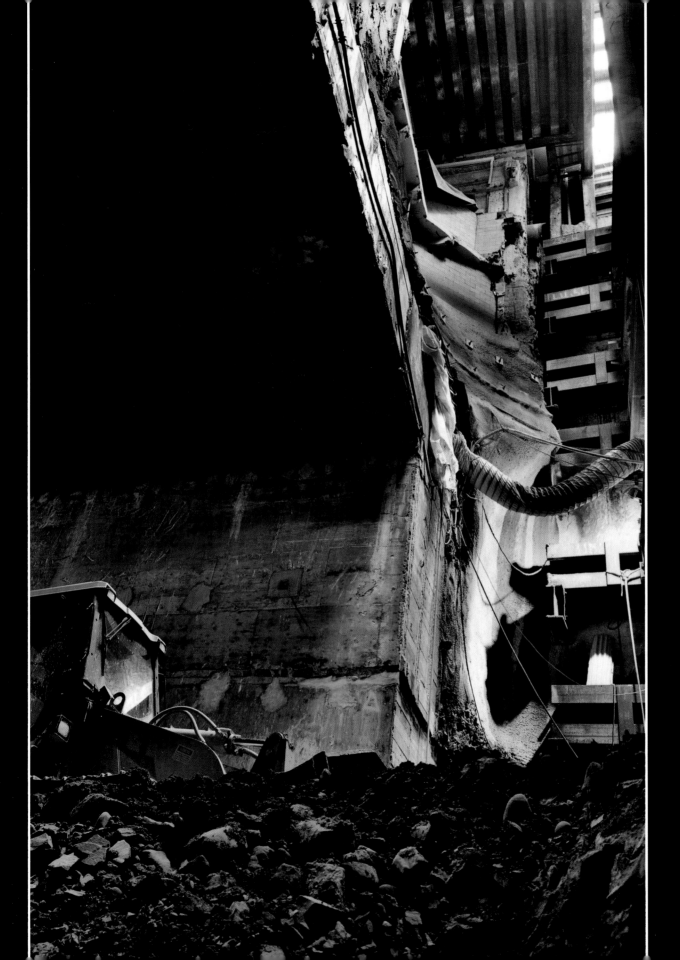

Left: 1:41 a.m.,
July 22, 1999.
One Financial Center.
Night Cats remove
dirt dumped here
in the 1830s to fill in
Boston's South Cove.

Right: 7:02 p.m.,
January 27, 2000.
Deep under One
Financial, a bulldozer
sits on glacial till
and points in the
direction of future
northbound vehicles.
"One hundred and
twenty feet beneath
Atlantic Avenue, we
built an underground
bridge for the Red
Line subway to pass
over I-93," explains
Joe Allegro, director
of construction for
the Big Dig.

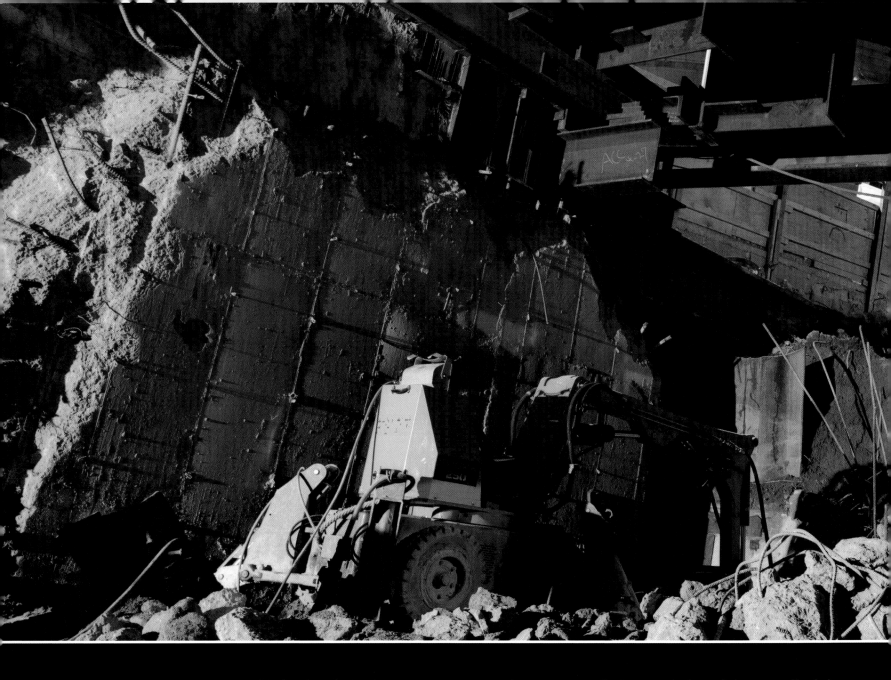

Under South Station, a remote-control excavator called a Brock demolishes a wall of the Federal Reserve Bank. "Armed guards from the bank were in the tunnel watching us to make sure our mined shafts didn't take an unplanned turn," says foreman Frank Nee. In the upper right, active water and electric lines are suspended by pipe hangers attached to grade girders at street level. 1:20 a.m., March 4, 1999.

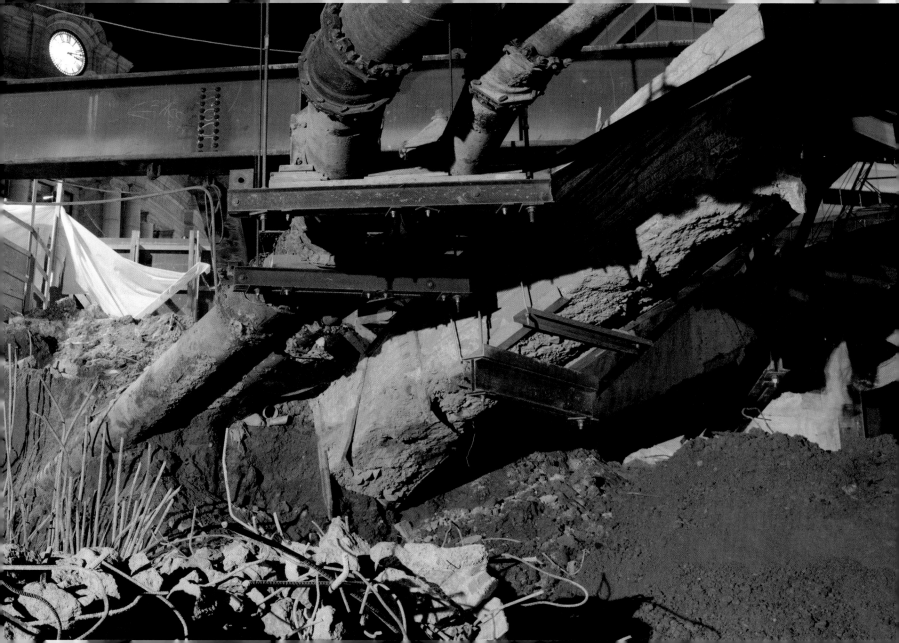

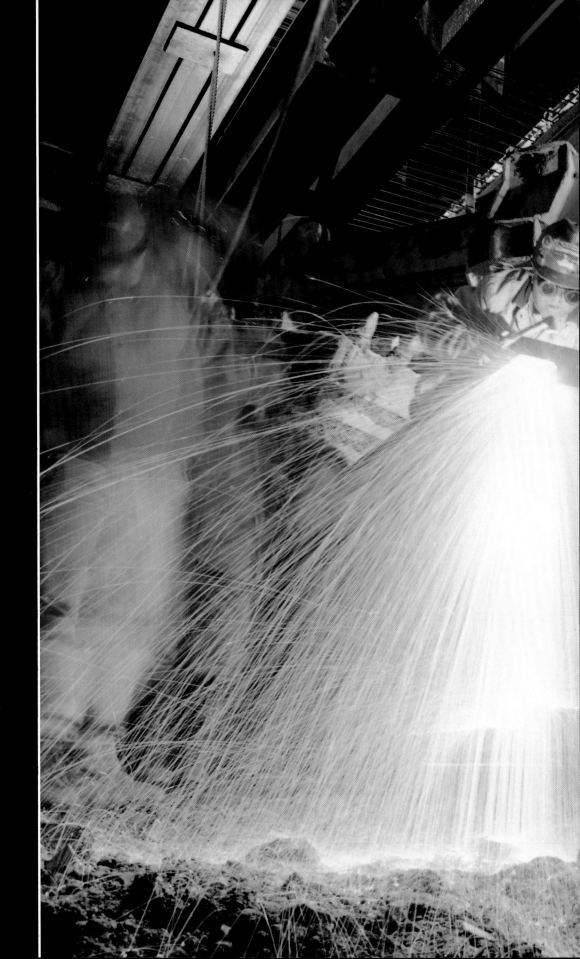

12:58 a.m., October 20, 1999. Over 100 feet below Atlantic Avenue. With the help of a Gradall tractor, Local 56 pile driver John Jordon performs strut installation as coworkers wait for him before breaking for "lunch" at 1:00 a.m. "Installing the struts with up to 940 tons of total load was scary enough, but when it came time to take them out of the hole, I was telling myself, 'there's got to be a better way of making a living.'" Fellow pile driver Jon Henry agrees. "These things are bigger than life." The enormous triple strut in the upper left is rare even on the Big Dig.

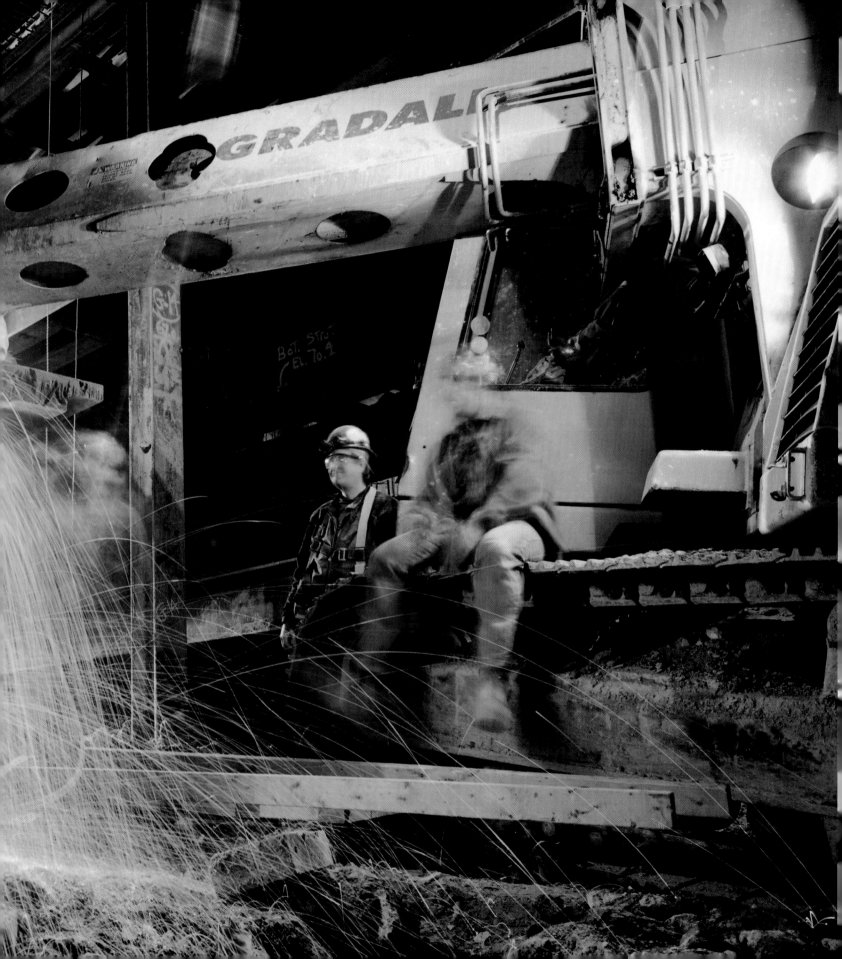

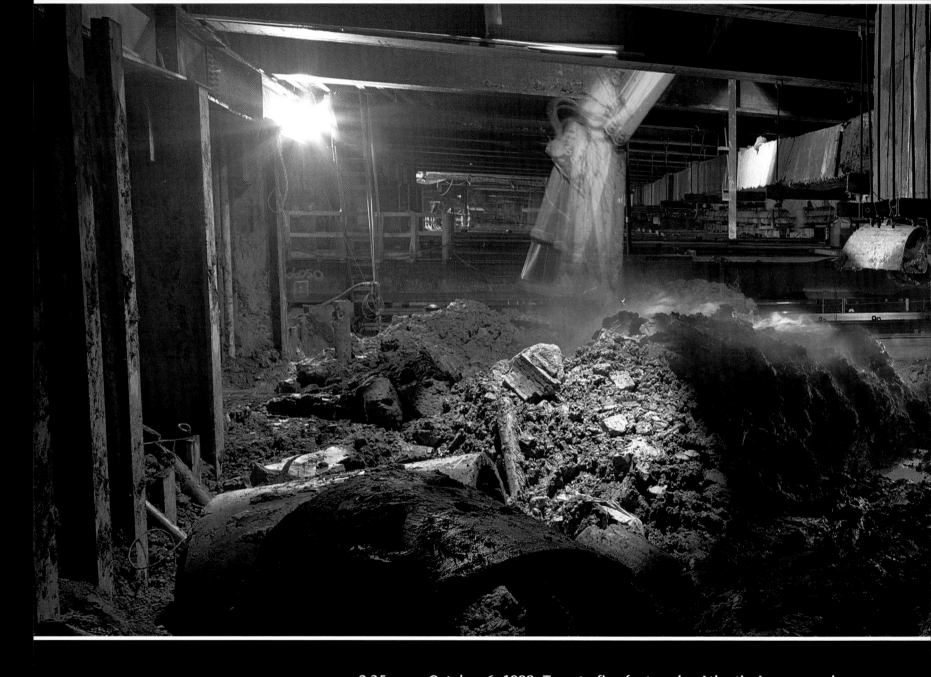

2:35 a.m., October 6, 1998. Twenty-five feet under Atlantic Avenue and
nearly 100 feet to go. Beneath Essex Street and unsuspecting pedestrians
and taxicabs outside South Station, two Gradalls maneuver under electric
lines as they pile steaming earth. Reaching through a glory hole, a backhoe

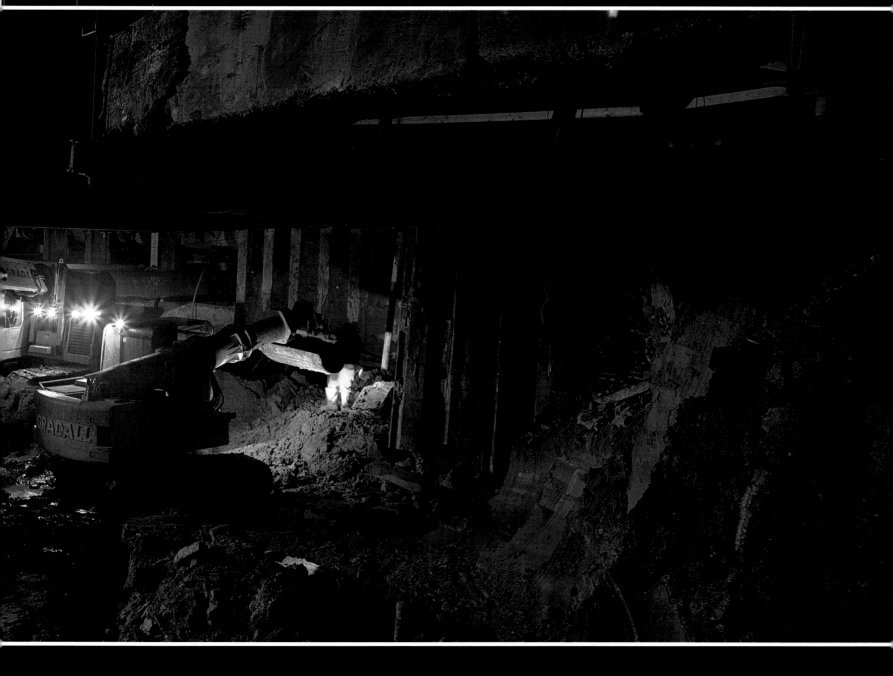

continuously fills seven large dump trucks on Atlantic Avenue. The trucks will
run nonstop throughout the night, hauling the dirt to Quincy, Massachusetts.
A public/private development group is creating a twenty-seven-hole golf course
on top of an old landfill, which will be covered with earth from the Big Dig.

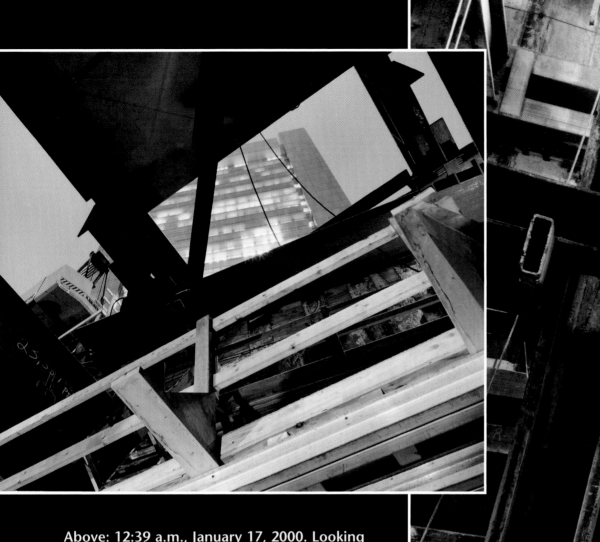

Above: 12:39 a.m., January 17, 2000. Looking past a catwalk and through the surface of Atlantic Avenue at the Federal Reserve Bank.

Right: 1:40 a.m., April 4, 2000.
The Bottom of the Big Dig's deepest tunnel. The bottoming-out beam, as the Night Cats called it, was the last cross-lot strut to be installed on this part of the project. It was painted a patriotic red, white, and blue by the union men and women who put it in.

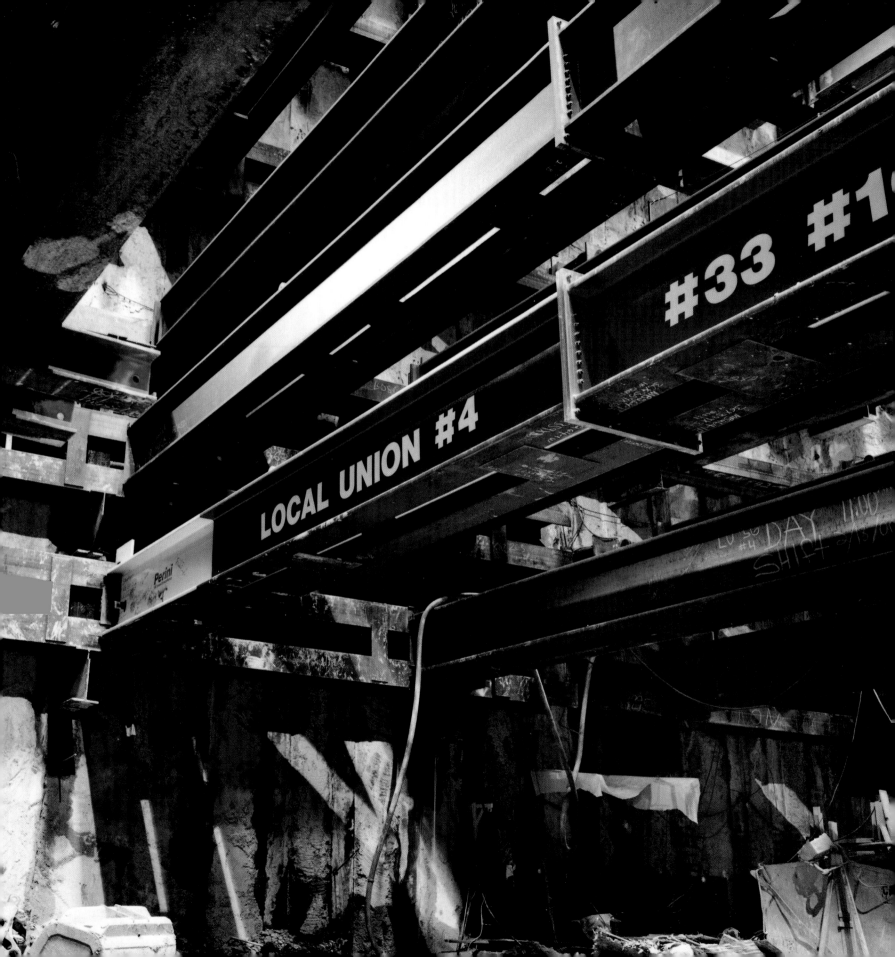

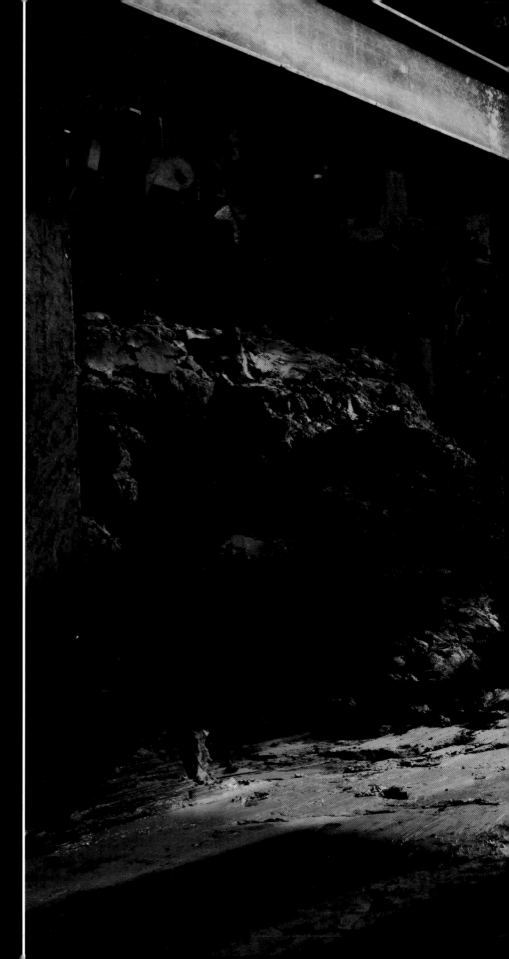

A 32-ton Gradall and its operator, Dennis Pirini, work in tandem deep beneath Atlantic Avenue. Before being filled in by previous generations, this site was part of Boston Harbor. Seen here, the unstable Boston Blue Clay, the harbor's natural bottom, has confounded some of the world's greatest engineers and created havoc for Local 4's best operators. Pirini is grading this portion of the I-93 tunnel for a four-inch concrete pour called a mud mat, the first layer of a 23-foot-thick roadbed.
3:56 a.m., November 5, 1998.

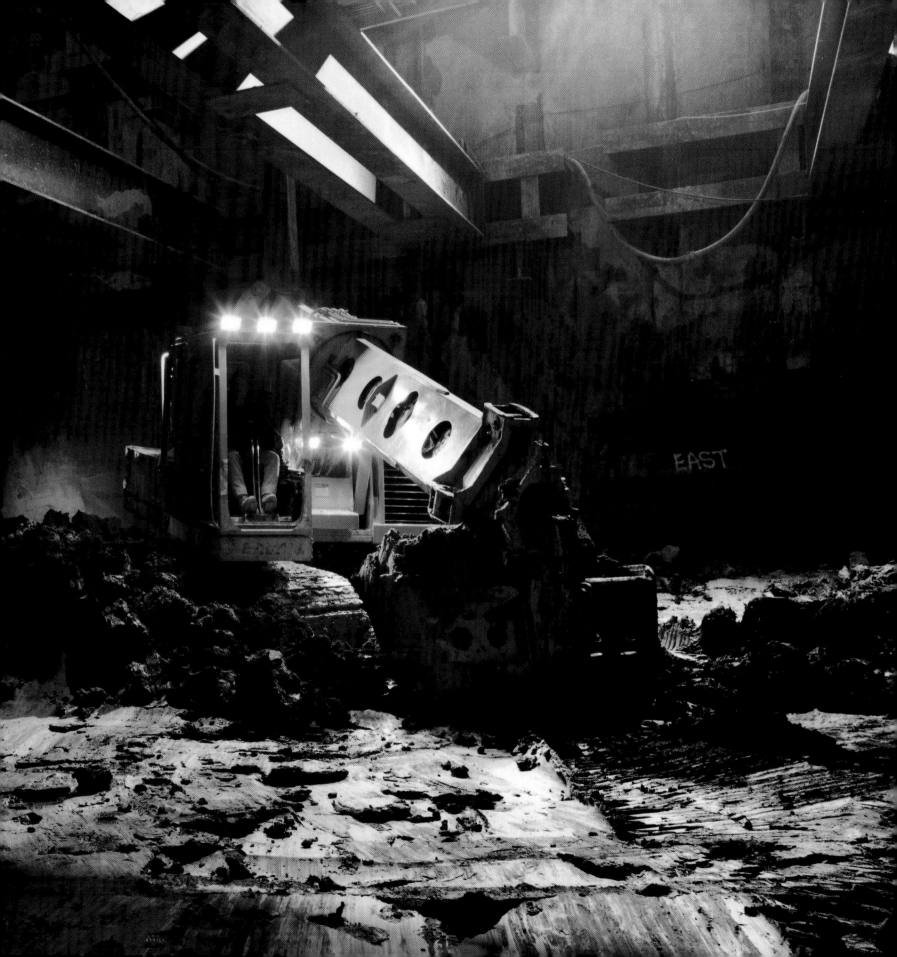

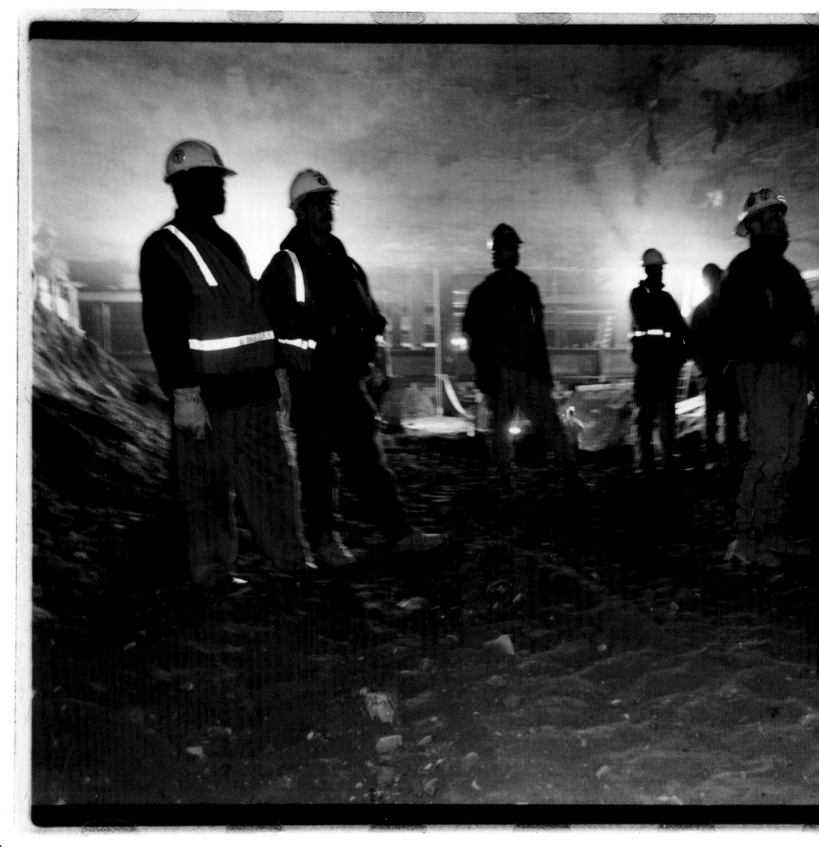

Breaking Through.
From shadowy corners far under the ground, Perini's Night Cats come together to bear witness to a critical milestone, successfully joining together the I-93 tunnel under the Red Line subway and connecting both ends of the Big Dig's deepest tunnel.
This milestone was accomplished quietly, with little fanfare.
When it was over, the Night Cats went back to work, building Boston's future. 1:19 a.m., December 9, 1999.

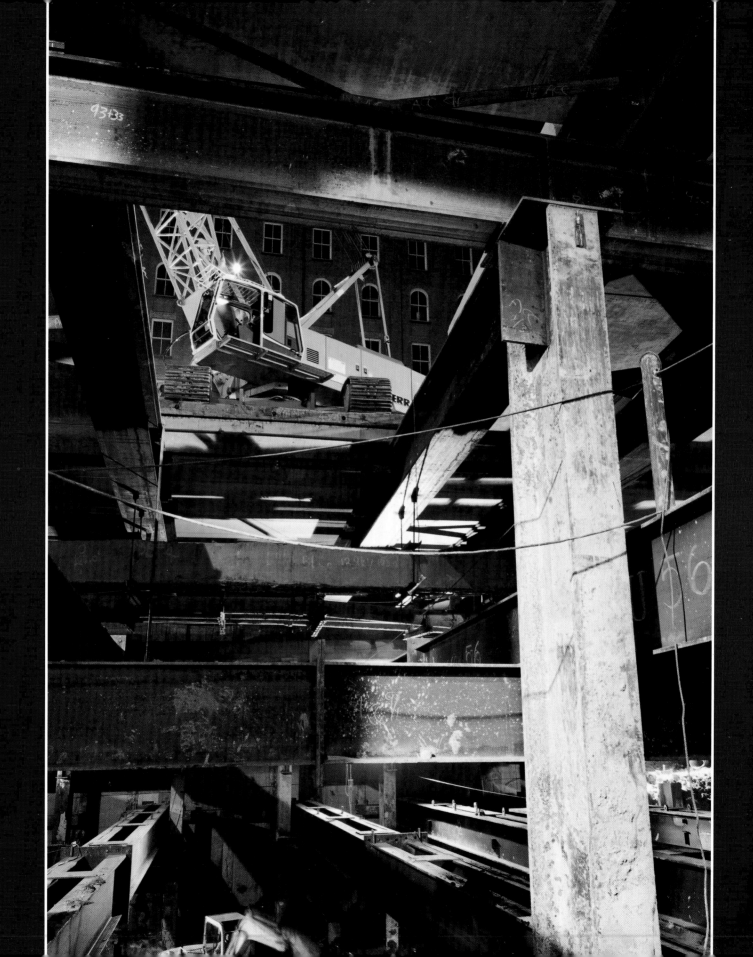

Stephen SetteDucati

In 1987 I moved from the open spaces of rural New York to Boston. As a photographer who shoots almost exclusively at night, I quickly became drawn to the glow of the cityscape. Then in 1996 the largest source of artificial light descended on Boston as the Big Dig began its slow grind into the earth. I soon began photographing this amazing project, concentrating on the construction along Atlantic Avenue known as C11A1. As Big Dig workers took notice of me, they began asking questions about my cameras and film. Friendships were forged, and within a few weeks, I was invited inside the construction gates. Going onto the site changed my view of the project forever.

Shooting at night heightens all of my senses. I tune in to the smell of diesel fuel, the whine of hydraulics, the spark of a welder, or the glow of mercury vapor work lights. I pay particular attention to the weather, noting elements like cloud cover, and I look forward to days of rain because the water provides an excellent reflecting source for light. A blanket of snow brings the level of light to almost daylight quality, even at 2:00 a.m.

My exposures extend from fifteen seconds to almost four minutes depending on the amount of ambient, artificial, and reflected light. The longer the exposure, the better 'paintability' light has. I do not use filters, nor do I use any added light. While I hide in shadows to prevent glare on the lens, I create my images directly in the viewfinder of the camera before triggering the shutter.

I have used three cameras to shoot the images in the book. My camera of choice is the Fuji 6X9, a lightweight medium-format viewfinder camera with a fixed 65mm lens. To control perspective, I use a circa 1940s 4X5 Crown Graphic press camera with a modern Schneider 90mm lens. When the image warrants a sweeping panoramic, I use the Fuji 6X17 Super Wide with a 90mm lens. Most of my early images were shot on Fuji Reala 100 negative film with up to four-minute exposures. Later, once I was allowed on-site and was under the project's high-intensity lights, I switched to Fuji NHG 800 negative film and brought my exposure times down to fifteen seconds. The majority of the images seen here are shot on Kodak 400 or 160 VC and NC films.

The images you see here would not have been at all possible without the help and encouragement of the following people: Dennis Allain, Richard Berenson, Joseph Favaloro, Derek Hanson, Bruce Kinch, Melissa Koff, Al MacPhail, Lorraine Marino, Joe McCarthy, Dan McNichol, Barbara Morgan, Frank Nee, Dennis Pirini, Rosemary Porto, Ron Richard, Matt Seel, Linda Silviri, the men and women of C11A1, C15A1, C19B1, and dozens of friends and family who understood my passion to document this incredible public works project. It has been my privilege to photograph history in the making, and I will continue to document this tremendous project as long as the work continues.

ACKNOWLEDGMENTS

Many articles, publications, and books were helpful in my research.
The following were particularly informative:

Mapping Boston, Alex Krieger, David Cobb, Amy Turner. MIT Press, 1999.

Boston: A Topographical History, Walter Muir Whitehill. Harvard University Press, 2000.

Boston's Central Artery, Yanni Tsipis. Arcadia Publishing, 2001.

The Creation of Bridges, David Bennett. Cartwell Books, 1999.

Public Roads, A Special Edition. Richard Weingroff.
United States Department of Transportation, 1996.

"Boston's Central Artery," Jack Scanlon. *New England Construction,* February 1952.

The Boston Globe

The *Boston Herald*

Writing *The Big Dig* and *The Big Dig at Night* has been an honor and a privilege,
and I owe a heavy debt of gratitude to many:

My publisher, Barbara Morgan, for her confidence, wisdom, and patience; Richard Berenson, Marjorie Palmer, and Marguerite Daniels for the highest professionalism and talent; the men and women of the Big Dig at Bechtel/Parsons Brinckerhoff; Modern Continental Company; Perini, Kiewit and Cashman; Local 4; The City of Boston; and the Massachusetts Turnpike Authority. A special and personal thanks to my mother, father, and sister, Meg, for their cheerleading and love; Erma Moore Ruskey for sharing her father's scrapbook on the original Central Artery; Melissa Koff for her endless encouragement and support; Lorraine Marino for her gracious assistance; Ken Anderson for his infinite wisdom with all things diesel driven; Stephen SetteDucati for his photographic genius; Richard Weingroff for putting the interstate in perspective. And finally, Bob Marsh and Andy Card for their inspiration to get involved.